Marcel van Eeden

K.M. Wiegand

Life and Work

MARCEL VAN EEDEN

K.M. WIEGAND
LIFE AND WORK

HATJE
CANTZ

THE INVENTION OF SOLITUDE

THE PATIENCE OF MARCEL VAN EEDEN

Massimiliano Gioni

A LIFE LESS ORDINARY

Last year in Warsaw, in what is probably the largest market in Eastern Europe, I bought a collection of photographs that used to belong to a man named Piotr Slowski. From what I gathered by looking at the 179 black-and-white pictures scrupulously arranged in an old family album, Piotr Slowski never took or collected a photo of himself. He never appeared in any of the images, nor did he portray people who could be easily identified as family members, lovers, children, or relatives. No trace of a wife—not even of a cousin. Piotr's collection of photos was devoid of life, or better, it was full of small signs of life, somehow even full of action, pulsating with many minuscule extraordinary events—and yet his images never seemed to deliver any sense of attachment, any sense of his own direct participation. Nobody ever appeared more than once in Slowski's photos. All the people captured by his camera clearly looked like strangers or marginal characters, often relegated to the background of the picture. If this album was how Slowski chose to document his life, it was a life lived by extras and secondary characters.

5

MAN WITHOUT QUALITIES

Marcel van Eeden's exquisite drawings have the same mysterious presence as Piotr Slowski's family; something ghostly emanates from van Eeden's graphite clouds, dark landscapes, and white shadows. Even if they betray an incredible enthusiasm for life in all its multifaceted manifestations, a Pantagruelic hunger for life and its images, Van Eeden's drawings always remain strangely removed from reality, detached. They are enveloped in a cold patina, which is amplified by the fact that all the drawings are identical in size and are systematically framed in identical frames. The process behind the drawings somehow remains inscribed in the paper, making them seem to be the products of a fastidious, even maniacal imagination. Marcel van Eeden, in fact, carries out his art-making with the same meticulousness that civil servants might invest in some bureaucratic procedure. For the past twelve years, Marcel van Eeden has been making a drawing a day, which currently amounts to more or less four thousand drawings. Every day, van Eeden picks up his pencil and begins a new drawing, starting from the top left corner of the paper, and ending at the bottom right corner. Every day he draws at least one picture, sometimes more, but never less than one.

AN ECOLOGY OF VISION

There is something monastic, even religious in van Eeden's meticulous obstinacy: his practice is almost a devotional exercise, which exists within a long lineage of rigorousness in conceptual art—Roman Opalka's lifelong numerological project comes to mind, or Gerhard Richter's *Atlas*.

But then again, in spite of his self-imposed discipline, van Eeden is also capable of extraordinary acts of ambition, verging on pure hubris. The artist is not simply making drawings of found pictures and old images. No, he wants to draw everything, the whole world. He is very open and candid about this: he is trying to draw every photographic image that preceded his birth, everything that occurred in a sort of nebulous zone that stretches from the beginning of the twentieth century to the year 1965, when, for no apparent reason, he happened to enter the stream of time. All those people walking down the streets or sitting in pubs and restaurants, those cars, trams and buses, those explosions, all the signs of life that animate van Eeden's drawings, well they all belong to the past; they are all cast away, lost, in the fog of a very private prehistory.

Half reporter and half archeologist, van Eeden has built a unique iconography by carefully selecting his sources from old newspapers, magazines, history books, primary school compendiums, found photographs, clippings and dated postcards—a chaotic depository of stories, which are removed from their original context and brought back to life by van Eeden's compulsive recycling of the past. This visual universe in fact seems affected by a radical form of iconophilia, an unstoppable urge to consume images and at the same time, by doing so, save them from oblivion.

It is an encyclopedia of death that van Eeden is composing. Of his own death, as he sometimes likes to refers to his project, but also an archive of countless lives disappearing in the past, fading away from our view, and forever receding into the background. By endlessly replicating images, by drawing over and over again the lives of people whom he has never met, Marcel van Eeden might be burying our ghosts— or resurrecting them.

Let Us Now Praise Famous Men

What do we leave behind? What are the traces, the crumbs of existence that remain to testify our passage through time? How do we prove that our lives have been lived?

So far, in his oeuvre, Marcel van Eeden has been concentrating on the nameless actors that sunk unnoticed into the darkness of history. And that's probably why his drawings have always appeared, to a certain extent, uneventful. Or better, they collate splinters of meaningful lives, but splinters so private and so minor that they could have been easily mistaken for worthless, marginal stories. It is the stuff we leave behind unnoticed that composes most of van Eeden's universe: he draws only what went on seemingly undisturbed by the great events of history. As seen through the lenses of his drawings, life appears a rather dull affair. But then again, who decides what makes a life worth living?

In Marcel van Eeden's new series of drawings though, things have started to shift in a different direction. While the creative process remains the same, and the sources of the images are still old books and photographs, van Eeden has now decided to focus on the life of a single person.

Karl McKay Wiegand was born somewhere in the United States in 1873 and died in 1942. Wiegand was a botanist, and not a very well known one. Marcel van Eeden simply found his name in an old book, just as he would have found a photo to reproduce in a drawing. But after this first encounter, Karl McKay Wiegand has been granted the privilege of living a new, incredibly exciting life. Van Eeden in fact has been inserting Wiegand into every one of his daily drawings, taking him on a rollercoaster ride through the twentieth century. In the over one hundred drawings that compose the series, we see Wiegand witnessing a series of extraordinary events: Wiegand climbs mountains, fights at the boxing

world championship, commands more than 373,000 men on a military expedition, and even marries Elizabeth Taylor. In his free time Wiegand now paints abstract pictures, writes books, stars in a couple of movies, and gets wounded during a terrorist attack.

Caught somewhere in between the Baron of Münchhausen and a sort of Zelig-like creature, Wiegand lives a surreal life, a sort of crazy hyperactive exercise, as though Marcel van Eeden was imagining all the different lives one mortal could live. In its overexcitement, the life of K. M. Wiegand seems to recall the adventures of Italo Calvino's characters or the endless possible worlds of a Georges Perec novel. Or more simply, as the artist himself explains, Wiegand is a kind of superhero, like the image that a child has of his own father.

But then again, as when flipping through the pages of Slowski's absurd family album, one cannot help finding something desperate in Marcel van Eeden's attempts to imagine such an extraordinary life for his new character. It is such a grandiose effort, possible even a tragicomical effort, that we are left wondering if such an eventful life is really any better than all those previously drawn by van Eeden. No matter how extraordinary our life is, how rich with surprises and revelations, what we will leave behind is nothing but a few faded images. And, unless somebody decides to rescue them from the past, they will remain silent and forgotten.

DIE ERFINDUNG DER EINSAMKEIT

DIE GEDULD DES MARCEL VAN EEDEN

Massimiliano Gioni

EIN NICHT GANZ GEWÖHNLICHES LEBEN

Vergangenes Jahr habe ich in Warschau auf dem wohl größten Markt Osteuropas ein Album mit Fotos gekauft, das früher einem gewissen Piotr Slowski gehört hatte. Nach Durchsicht der 179 sorgfältig zu einem alten Familienalbum arrangierten Schwarzweißfotos gelangte ich zu der Vermutung, dass Piotr Slowski niemals ein Foto von sich gemacht oder gesammelt hat. Er ist weder auf einem der Fotos abgebildet, noch hat er Menschen porträtiert, die sich ohne weiteres als Familienangehörige, Geliebte, Kinder oder sonstige Verwandte identifizieren ließen. Kein Hinweis auf eine Ehefrau – oder auch nur auf einen Cousin. In Piotrs Fotosammlung fand Leben einfach nicht statt, genauer gesagt: Die Sammlung enthielt eine Fülle kleiner Lebenszeichen, zahllose Hinweise auf menschliche Aktivitäten sowie auf belanglose, dennoch außergewöhnliche Ereignisse. Trotzdem war auf den Bildern nirgends ein Zeichen von persönlicher Anhänglichkeit oder gar von unmittelbarer Betroffenheit von ihm zu entdecken. Keine einzige Person war auf Slowskis Fotos öfter als einmal abgebildet. Sämtliche Gestalten, die er mit seiner

Kamera eingefangen hatte, waren offenbar Fremde oder Leute gewesen, denen er nur flüchtig begegnet war, häufig waren sie sogar in den Hintergrund des Bildes verbannt. Falls es Slowskis Wunsch gewesen ist, in diesem Album sein Leben zu dokumentieren, so war es ein von Statisten und sekundären Figuren gelebtes Dasein.

MANN OHNE EIGENSCHAFTEN

Marcel van Eedens exquisite Zeichnungen besitzen die gleiche mysteriöse Präsenz wie Piotr Slowskis Familie: Aus den Graphitwolken, den dunklen Landschaften und den weißen Schatten van Eedens taucht etwas Geisterhaftes auf. Obwohl aus diesen Arbeiten eine unglaubliche Begeisterung für das Leben in all seinen Erscheinungsformen, ein pantagruelischer Lebens- und Bilderhunger spricht, präsentierten die Zeichnungen die Realität stets in einer merkwürdig distanzierten Manier, unbeteiligt. Die Darstellungen scheinen geradezu von einer Patina der Kälte umschlossen, die noch dadurch verstärkt wird, dass sämtliche Zeichnungen ein und dasselbe Format haben und völlig gleich gerahmt sind. Der Prozess, dem die Blätter ihre Entstehung verdanken, ist dem Papier dauerhaft eingeschrieben. Daher erscheinen die Bilder wie die Produkte einer wählerischen, ja fast manischen Einbildungskraft. Und in der Tat widmet sich Marcel van Eeden seinem Kunstschaffen mit derselben Gründlichkeit, die man auch dem zum Klischee geronnenen Beamten nachsagt, der pedantisch seine Pflicht erfüllt. Seit nunmehr zwölf Jahren macht Marcel van Eeden Tag für Tag eine Zeichnung, sodass sich deren Gesamtzahl inzwischen auf rund viertausend Blätter beläuft. Jeden Tag nimmt van Eeden seinen Stift zur Hand und beugt

sich über eine neue Zeichnung, die er oben links auf dem Blatt beginnt und unten rechts enden lässt. Jeden Tag zeichnet er wenigstens ein Bild, manchmal auch mehr, mindestens aber eines.

EINE ÖKOLOGIE DES BLICKS

Die unerschütterliche Beharrlichkeit, mit der van Eeden zu Werke geht, hat etwas Religiöses, ja fast Mönchisches an sich: Seine Vorgehensweise erinnert an eine Andachtsübung und steht damit in der Tradition des für die Konzeptkunst typischen Rigorismus, durch den sich etwa das Zahlenprojekt eines Roman Opalka auszeichnet oder Gerhard Richters *Atlas* betitelte Fotoenzyklopädie.

Trotz dieser bewundernswerten Übung in Selbstdisziplin lässt van Eeden sich bei anderer Gelegenheit zu außerordentlich ambitionierten Taten hinreißen, die schon an Hybris grenzen. Der Künstler macht nämlich nicht nur Zeichnungen von gefundenen oder alten Bildern. Nein, er möchte alles zeichnen: die ganze Welt. In diesem Punkt ist er ganz offen, er möchte jedes fotografische Bild zeichnen, das vor seiner Geburt entstanden ist – alles, was in der nebulösen Zone zwischen dem Anfang des 20. Jahrhunderts und 1965 stattgefunden hat, als der Künstler aus keinem nachvollziehbaren Grund zufällig in den Strom der Zeit eingetreten ist. Sämtliche Menschen, die auf der Straße unterwegs sind oder in Bars und Restaurants sitzen, alle Autos, Straßenbahnen und Busse, alle Explosionen, alle Lebenszeichen, die van Eedens Zeichnungen bevölkern – nun ja, sie alle gehören der Vergangenheit an, verschollen, verschwunden im Nebel einer sehr privaten Prähistorie. Halb Reporter, halb Archäologe hat Van Eeden eine einzigartige Ikonografie geschaffen. Seine sorgfältig ausgesuchten Motive findet er in alten Zeitungen und

Illustrierten, Geschichts- und Grundschulbüchern. Bisweilen dienen ihm aber auch alte Fotos oder Postkarten als Vorlage: ein chaotisches Repertoire an Geschichten, die van Eeden – ihrem ursprünglichen Zusammenhang entfremdet – durch sein fast zwanghaftes Vergangenheitsrecycling zu neuem Leben erweckt. Tatsächlich verdankt sich dieses visuelle Universum einer radikalen Form der Ikonophilie, einem unaufhaltsamen Drang, Bilder zu konsumieren und sie damit der Vergessenheit zu entreißen.

Allerdings könnte man van Eedens Schaffen auch als Enzyklopädie des Todes bezeichnen, und zwar seines eigenen Todes, wie er selbst sein Projekt bisweilen charakterisiert. Doch zugleich haben wir es bei seinem Werk mit einem Archiv zahlloser Existenzen zu tun, die in der Vergangenheit verschwinden, sich unserem Blick entziehen und sich unwiederbringlich immer weiter von uns entfernen. Durch die endlose Wiederholung bereits vorhandener Bilder, durch die hartnäckige Praxis, Momente aus dem Leben immer neuer, ihm persönlich völlig unbekannter Menschen zeichnerisch festzuhalten, erweist sich Marcel van Eeden einerseits als Bestatter der Gespenster der Vergangenheit – während er diese andererseits gerade zu neuem Leben erweckt.

Nun lasst uns Lob den edlen Männern singen

Was bleibt von uns zurück? Welche Spuren, welche Krümel des Daseins werden künftig einmal davon künden, dass wir hier gewesen sind? Wie können wir beweisen, dass wir tatsächlich gelebt haben?

Bislang hat Marcel van Eeden sich in seinem künstlerischen Schaffen vornehmlich jenen namenlosen Akteuren gewidmet, die der Dunkelheit der Geschichte fast unbemerkt anheim gefallen sind. Das ist

wohl auch der Grund dafür, weshalb auf seinen Zeichnungen meist so wenig passiert. Besser gesagt: Diese Zeichnungen stellen einfach Splitter bedeutungsvoller Existenzen nebeneinander – freilich Splitter, die so privat, so belanglos sind, dass man sie leicht als wertlose, marginale Erzählungen missverstehen könnte. Doch in van Eedens Universum sind gerade jene Sachen von Belang, die wir sonst achtlos liegen lassen. Er hält mit dem Zeichenstift nur Dinge fest, die von den großen Umwälzungen der Geschichte irgendwie unberührt erscheinen. Durch die Linse seiner Zeichnungen betrachtet, präsentiert sich das Leben zwar als eintönige Angelegenheit, doch wer vermag schon zu sagen, was den Wert eines Lebens ausmacht?

Die Serie von Zeichnungen, mit der sich van Eeden neuerdings beschäftigt, geht jedoch in eine andere Richtung. Die künstlerische Vorgehensweise selbst ist zwar gleich geblieben, Van Eeden entnimmt seine Motive weiterhin alten Büchern und Fotografien. Allerdings hat er beschlossen, seine ganze Aufmerksamkeit jetzt dem Leben eines einzelnen Menschen zu widmen.

Karl McKay Wiegand wurde 1873 irgendwo in den Vereinigten Staaten geboren und starb 1942. Wiegand war Botaniker und nicht sonderlich bekannt. Marcel van Eeden ist rein zufällig in einem alten Buch auf den Namen des Mannes gestoßen – wie er ansonsten Fotos als Vorlage für seine Zeichnungen findet. Nach dieser ersten Begegnung hat der Künstler beschlossen, Karl McKay Wiegand mit einem neuen, ungemein aufregenden Leben zu beglücken. Tatsächlich verewigt Van Eeden seine neue Hauptfigur seit einiger Zeit täglich auf einer Zeichnung und lässt den Botaniker auf diese Weise eine wahre Achterbahnfahrt durch das 20. Jahrhundert unternehmen. Die inzwischen mehr als hundert Wiegand-Blätter zeigen die Figur im Zentrum wichtiger Ereignisse: Wiegand besteigt Berge, er kämpft um die Boxweltmeisterschaft, er befehligt über 373 000 Soldaten bei einer militärischen Expedition und heiratet

sogar Elizabeth Taylor. Neuerdings malt Wiegend in seiner Freizeit abstrakte Bilder, er schreibt Bücher und wirkt in mehreren Filmen mit. Außerdem wird er bei einem Terroranschlag verletzt.

Wiegand ist eine Mischung aus dem Baron von Münchhausen und Zelig: Die Figur führt ein surreales Leben und legt einen völlig verrückten Hyperaktivismus an den Tag. Ja, es scheint fast so, als ob Marcel von Eeden sämtliche Situationen zeigen möchte, in die ein Sterblicher überhaupt geraten kann. So gesehen erinnert K. M. Wiegands überdrehtes Leben an Italo Calvinos Figuren oder an die endlosen Möglichkeitswelten eines Georges Perec. Wir können aber – wie der Künstler selbst es vorgeschlagen hat – in Wiegand auch eine Art Superman sehen, ein überlebensgroßes Idealbild, wie es Kinder in einer bestimmten Phase vom eigenen Vater haben.

Wie Slowskis absurdes Familienalbum hat auch Marcel van Eedens Versuch, sich für seine neue Figur ein so durch und durch außergewöhnliches Leben auszudenken, etwas Verzweifeltes an sich. Das grandiose, vielleicht sogar tragikomische Projekt stellt uns vor die Frage: Ist ein derart ereignisreiches Leben wirklich wünschenswerter ist als jenes unspektakuläre Dasein, das van Eeden auf seinen früheren Zeichnungen immer wieder dokumentiert hat? Wie außergewöhnlich, wie reich an Überraschungen und Offenbarungen ein Leben auch sein mag – ein paar verblasste Bilder sind schon alles, was von uns bleibt. Falls niemand den Entschluss fasst, sie der Vergangenheit zu entreißen, werden sie zudem auf ewig stumm bleiben und einfach in Vergessenheit geraten.

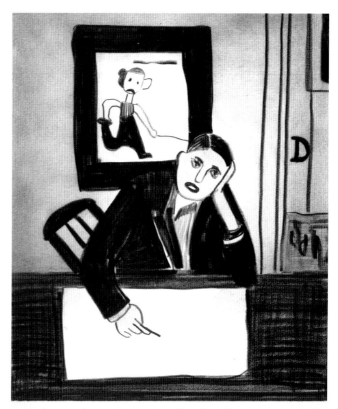

This watercolour by Karl Wiegand, aged
nine, graphically illustrates the feeling
of every young artist when contempla-
ting a blank sheet of paper.

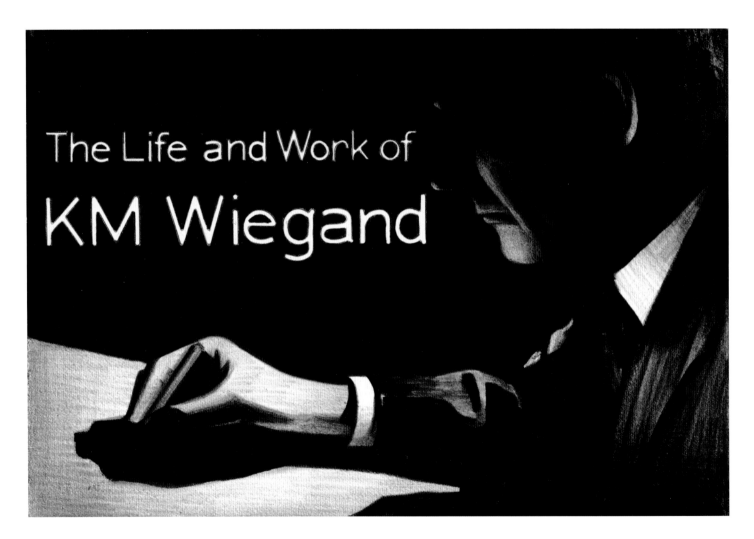

The Life and Work of
KM Wiegand

K.M. Wiegand, 'in albis, 21–4–63'
Öl, 120 × 170 cm

K. M. Wiegand, 'Modell für einen Brunnen'
Mischtechnik, 137 x 122 cm

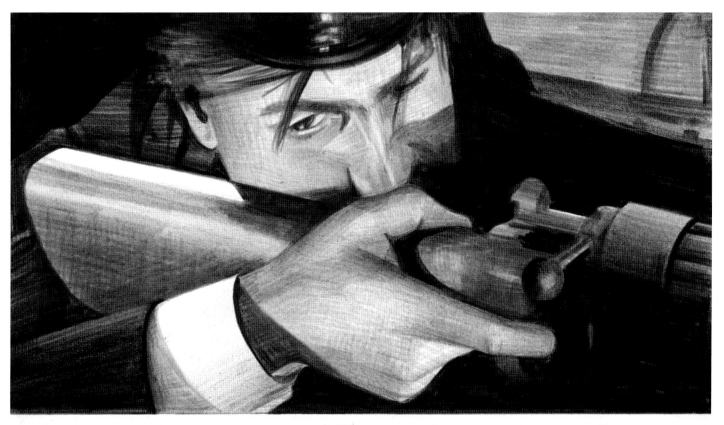

Karl M. Wiegand, der „König der Hochstapler" der
Nachkriegszeit. Sechs Jahre Zuchthaus und Sicher-

IN HIS EARLIER
YEARS WIEGAND
WAS BEST KNOWN
AS AN ACE PILOT
AND SQUIRE OF
BEAUTIFUL WOMEN

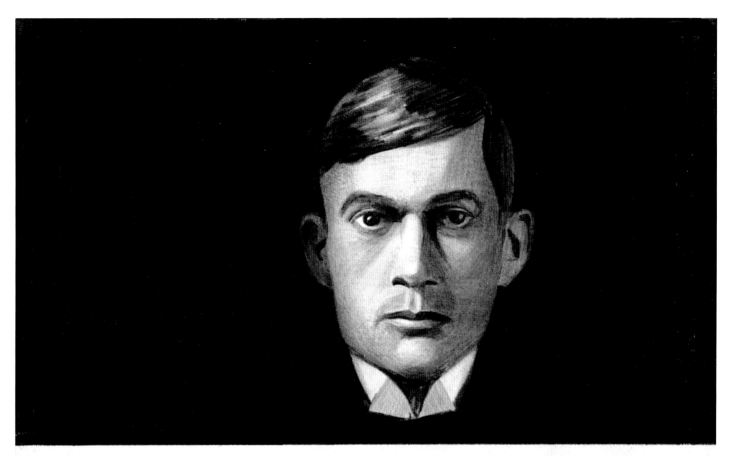

K.M. Wiegand

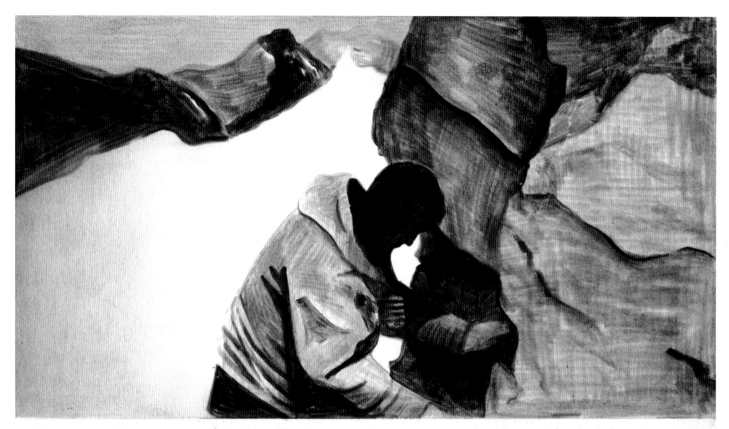

Geologist at work. Twenty-two year old Karl Wiegand, soon to be overtaken by misfortune, examines a rockface.

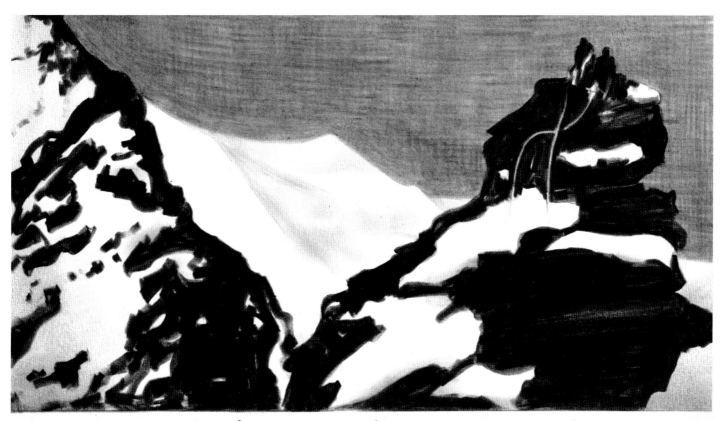

During a reconnaissance to find a way through the mountains, Heaney and Wiegand scale a peak. Fog

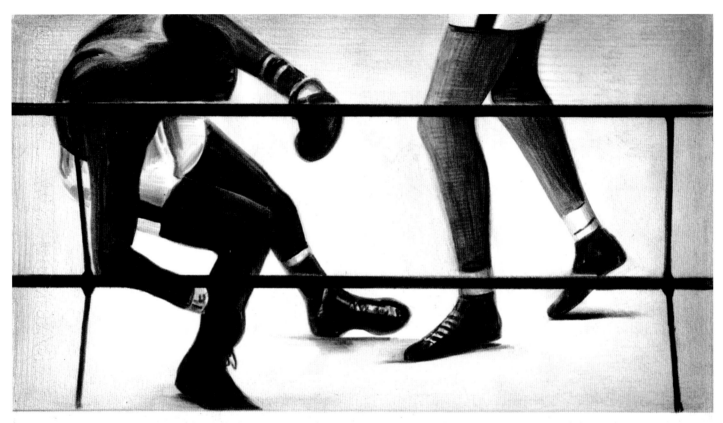

K.M. Wiegand, right, qualified as top contender with a first-round knockout over Eddie Machen last September.

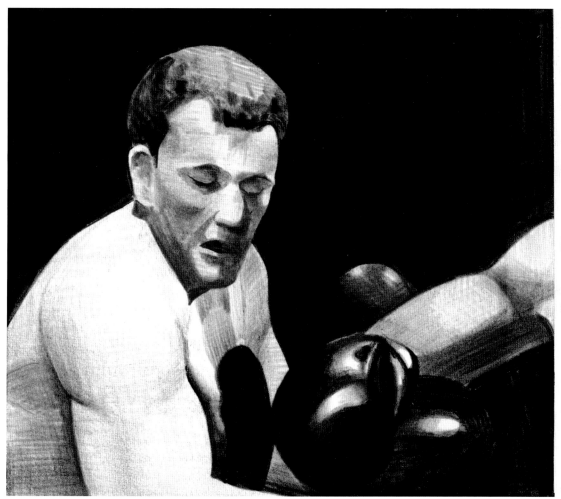

Wiegand clips Brian London with vicious right in tune-up fight before meeting Johansson. He scored a K.O. in the 11th round.

81

27

HAUS
AM
WALDSEE

BERLIN

KM WIEGAND

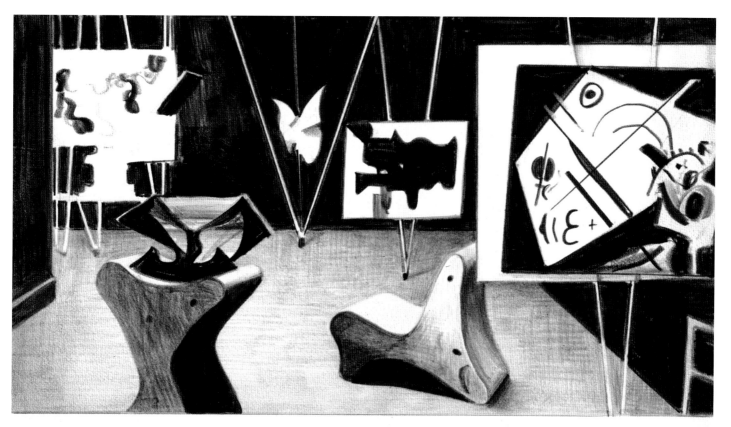

K.M. Wiegand
Haus am Waldsee, Berlin

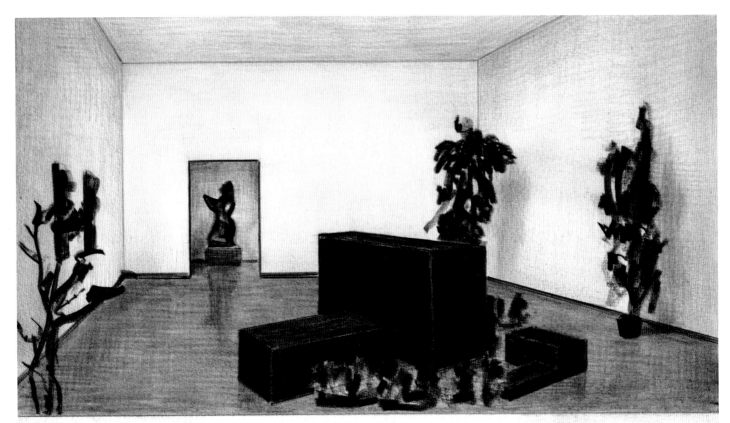

K. M. Wiegand

Haus am Waldsee, Berlin

K. M. Wiegand
Haus am Waldsee, Berlin

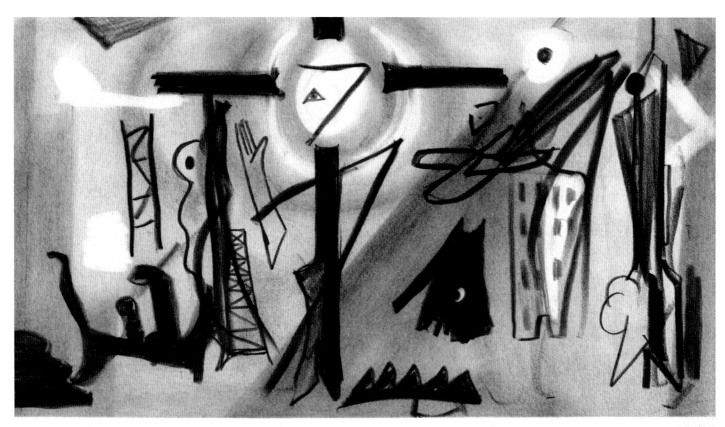

K. M. Wiegand, 'Figurative Zeichen'
Öl auf Leinwand , 132 x 170 cm

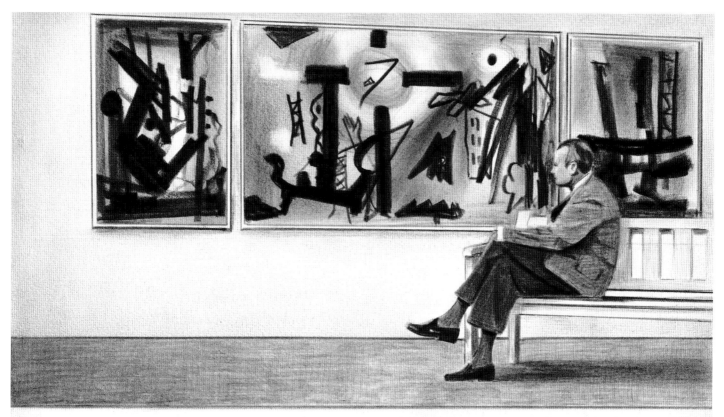

K.M. Wiegand
Haus am Waldsee, Berlin

K. M. Wiegand
Haus am Waldsee, Berlin

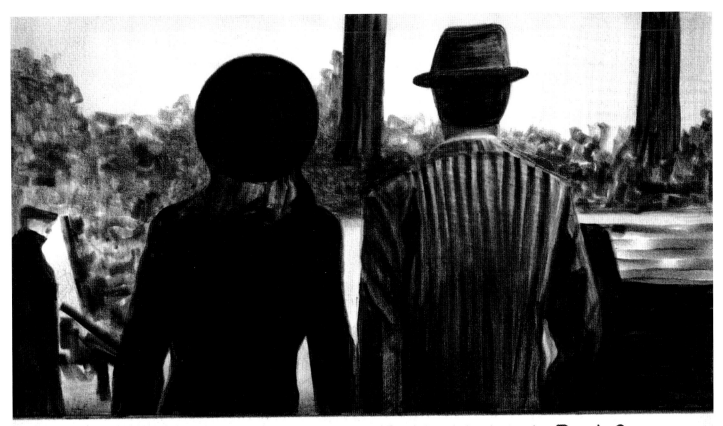

WER SCHLENDERT HIER Hand in Hand durch Paris? –
K.M. Wiegand und Rita Hayworth glauben sich unbeobachtet

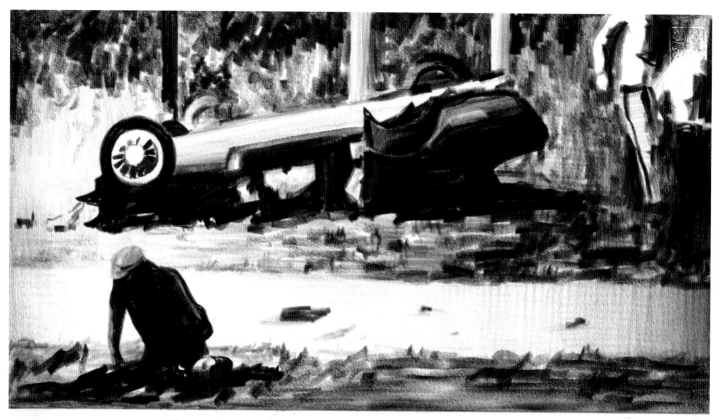

Un docteur (à g.) achève d'examiner Karl Wiegand qui a
été éjecté de son siège après avoir pris trop vite un vi-

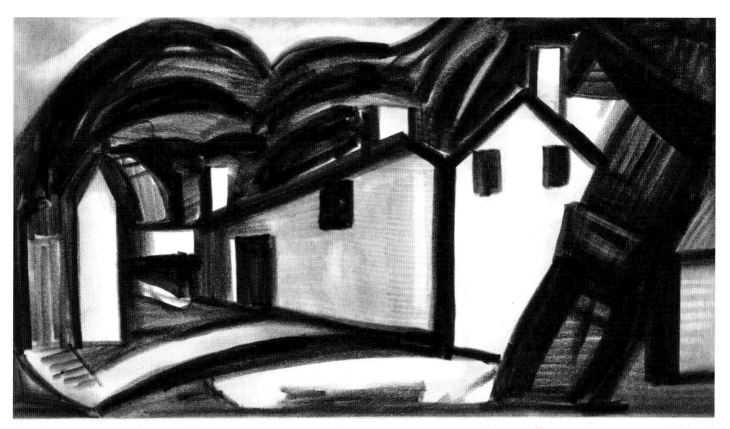

Der Preis ist K.M. Wiegand zugesprochen für sein Bild „Häusergruppe", das damit in den Besitz der hannover-

K.M. Wiegand, 'I like this flower'
Öl, 100 x 130 cm

"It's titled Motivation"

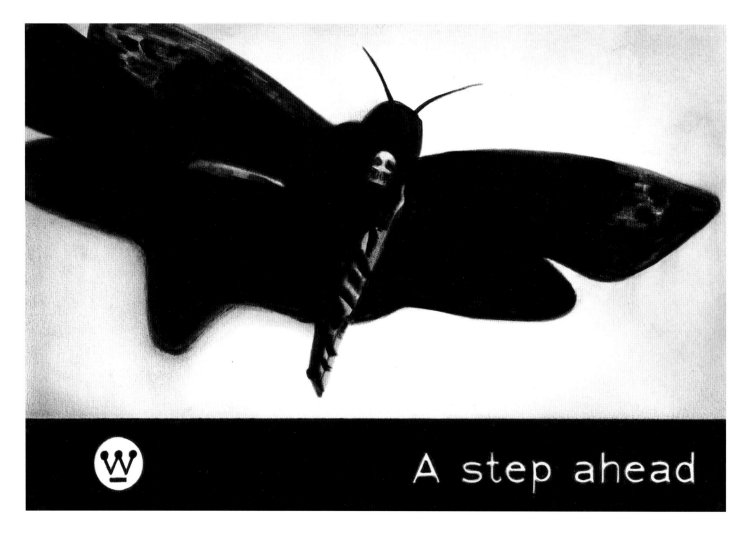

A step ahead

40

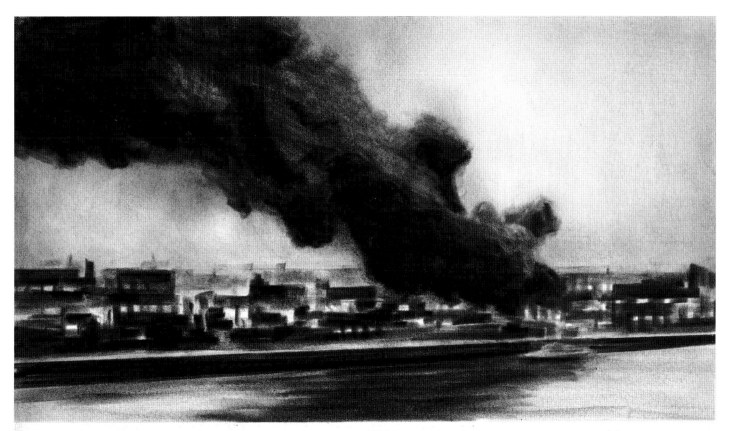

The Fighting Lady, 1944. Filmed in color by the
renowned and venerable photographer, K.M. Wiegand,

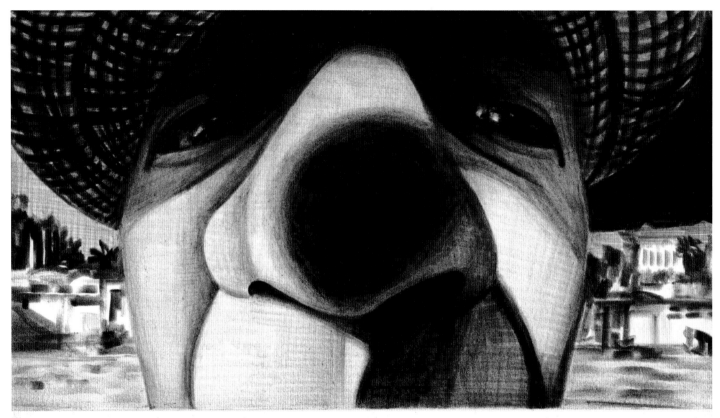

Wiegand, the master of distortion, faces a "fish-eyed" photographer.

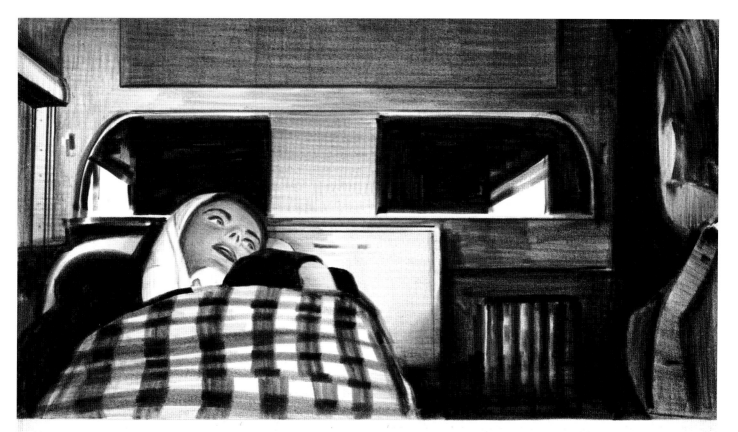

Unmittelbar, nachdem sie Karl Wiegand geheiratet hatte, mußte Elizabeth Taylor ins Krankenhaus ein-

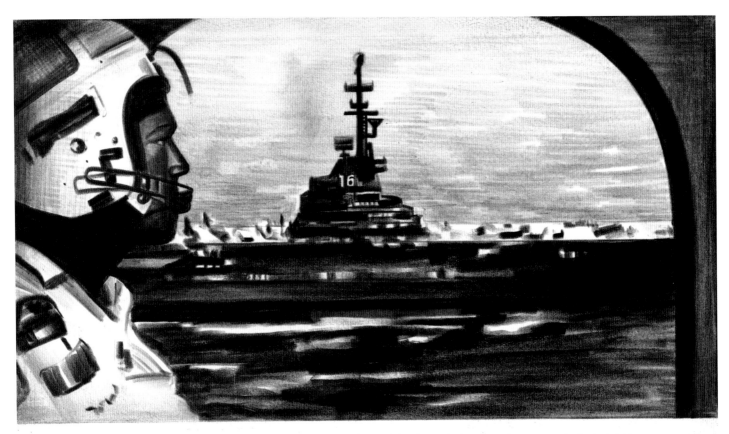

U.S. COMMANDER in the Pacific, Admiral K.M.Wiegand directs a defense force of 373,000 men.

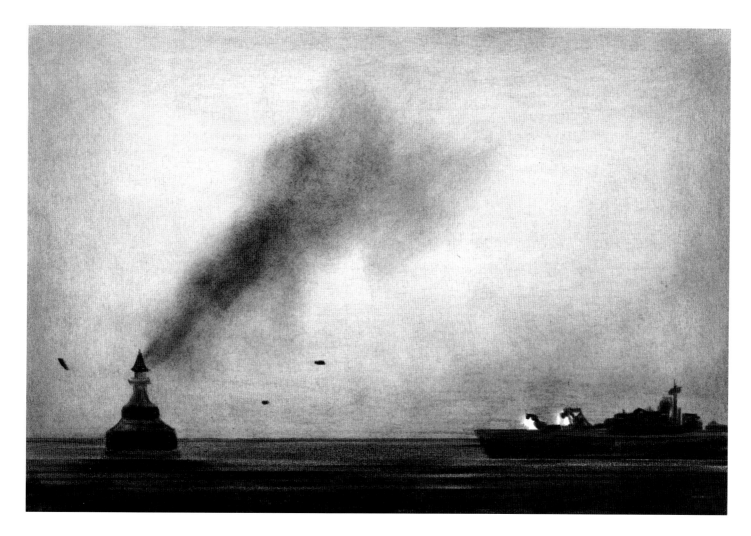

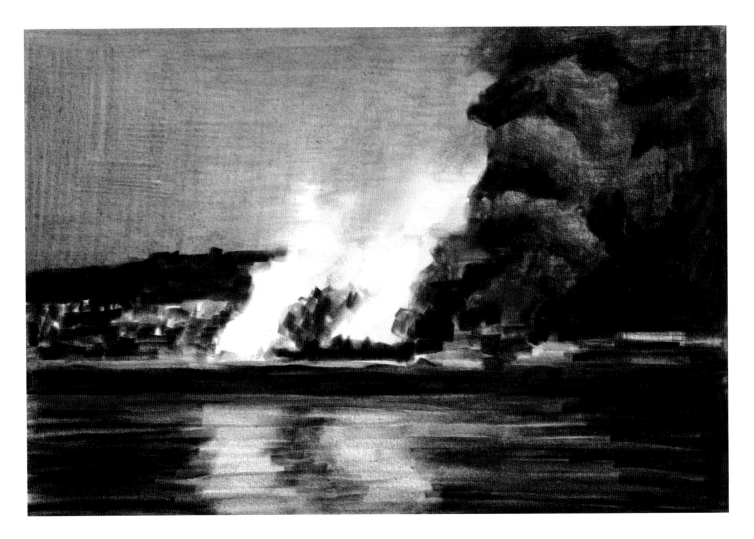

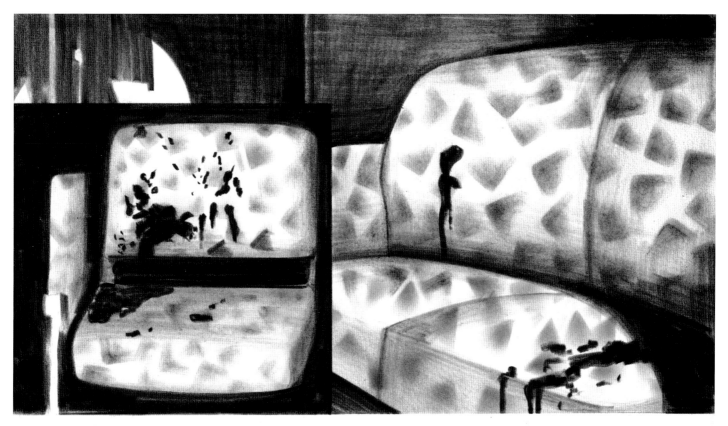

Sur les coussins de la voiture, partout le sang
a giclé. Tragique et vaine pièce à conviction, l'auto-

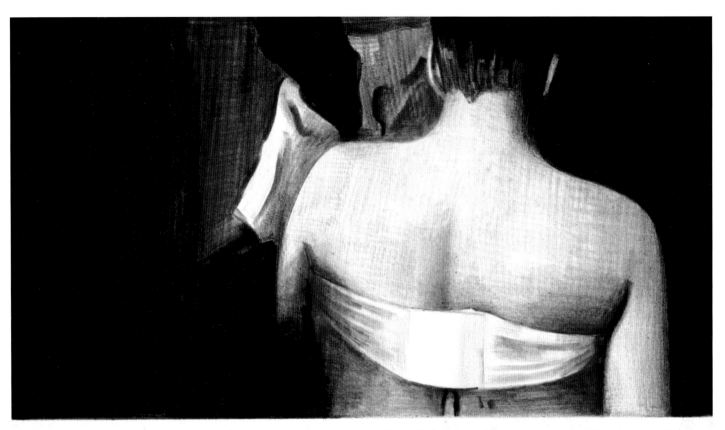

Bandage covers the wounds of K.M. Wiegand, a reporter
for the Associated Press in Memphis. He was caught in

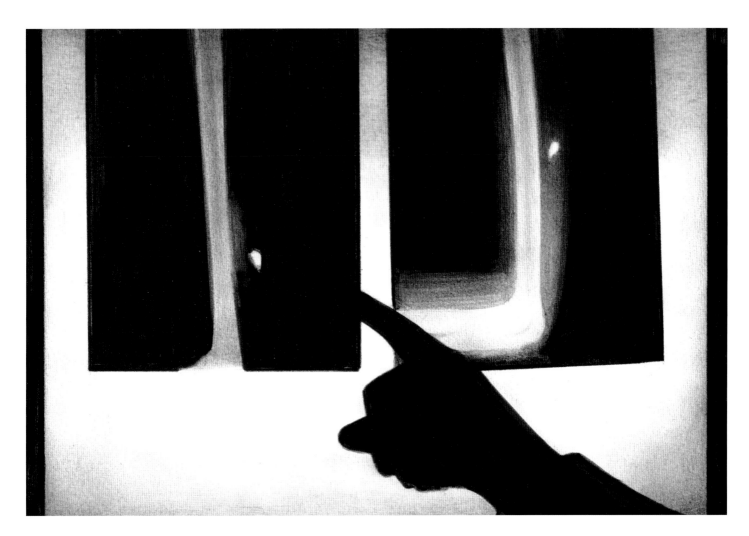

49

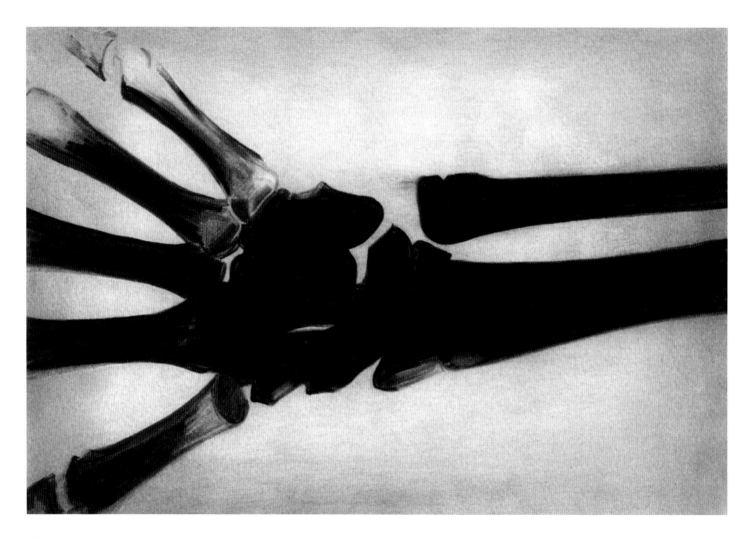

50

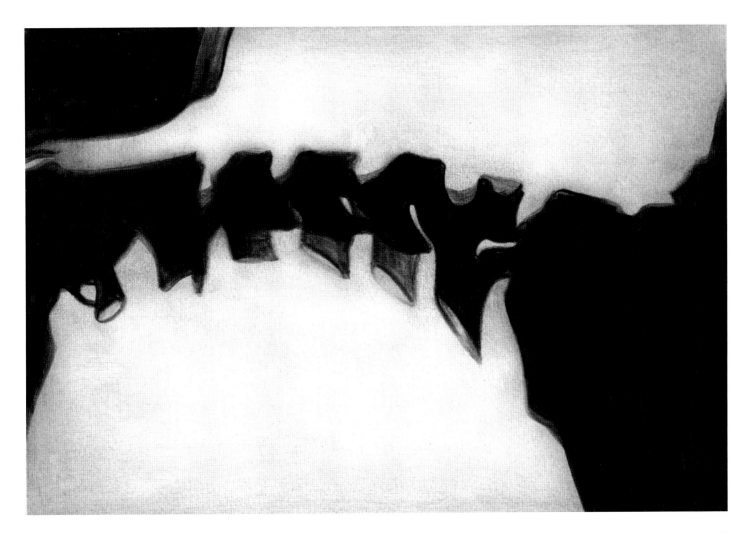

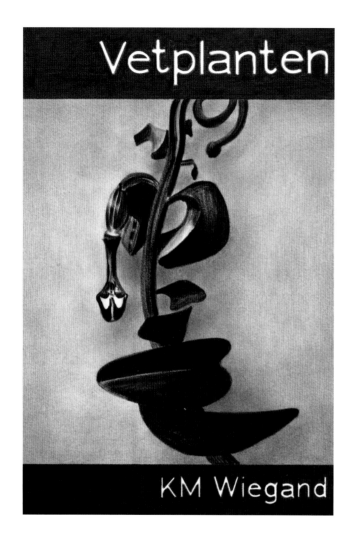

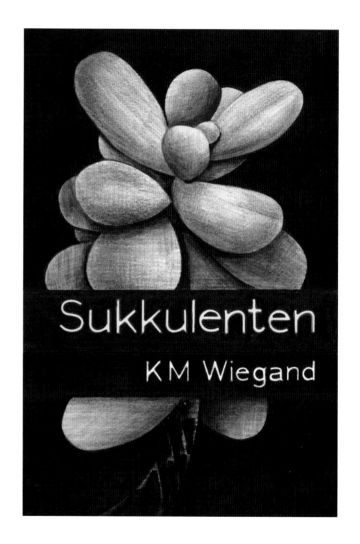

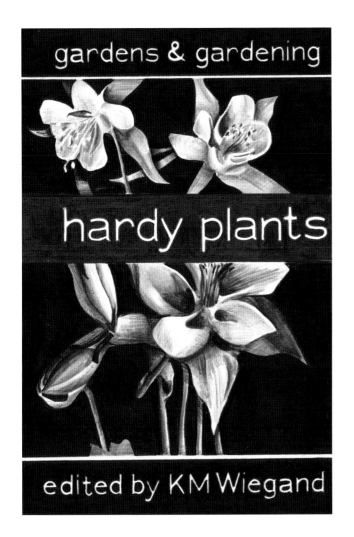

gardens & gardening

hardy plants

edited by KM Wiegand

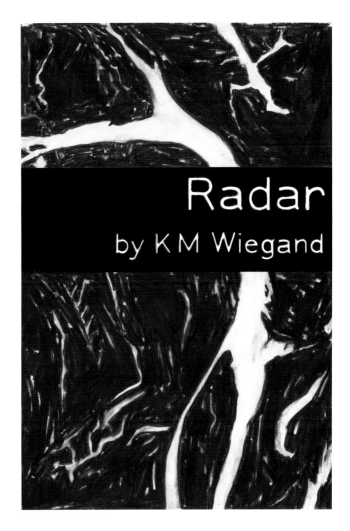

Radar

by KM Wiegand

54

COTYLEDON MACULATA

(FOTO: WIEGAND)

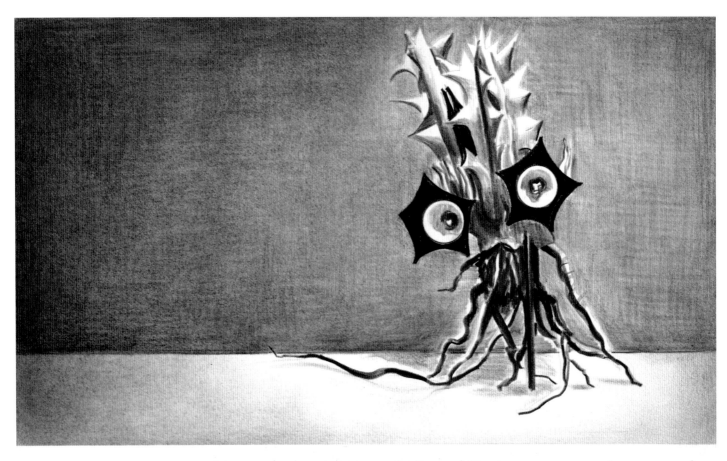

HEURNIA OCULATA (Foto K.M. Wiegand)

Carex wiegandii

59

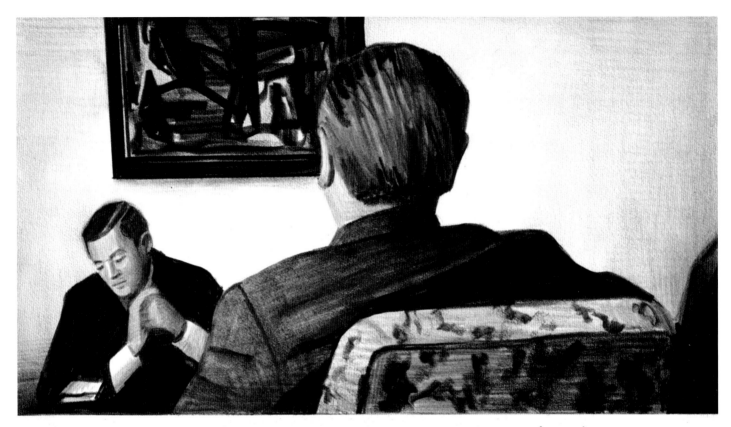

INTERVIEWING K.M.WIEGAND, John Mulliken (left) consults his notes while directing questions at the Chancellor.

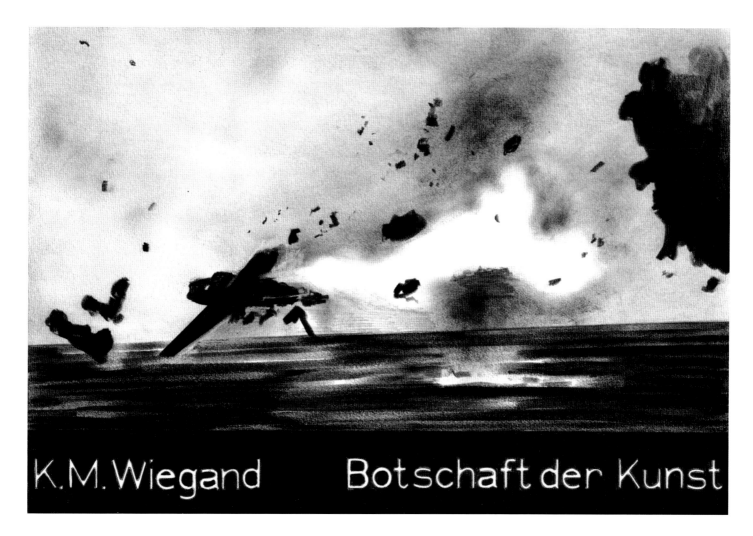

K.M.Wiegand Botschaft der Kunst

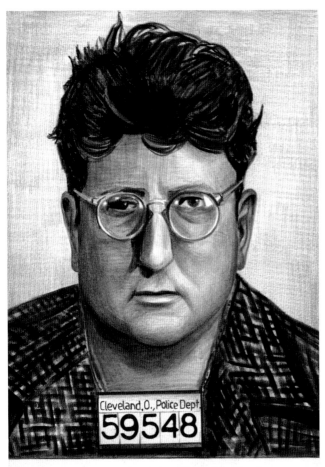

Georg Axhausen

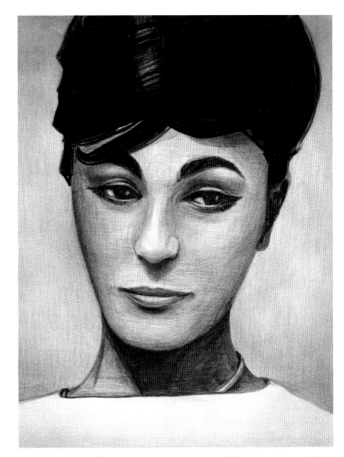

Mrs. Wiegand, 1963

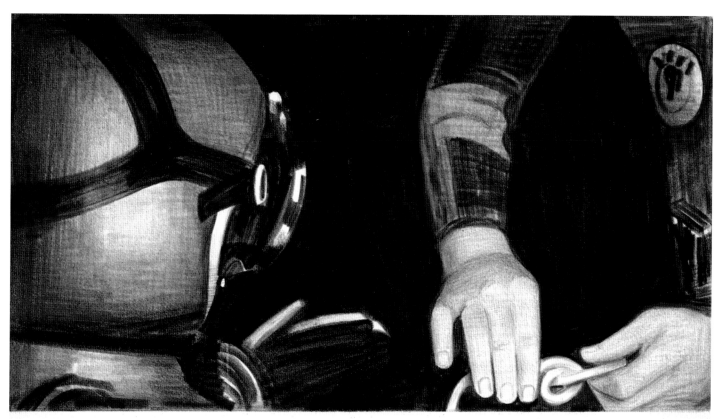

Wiegand attache au poignet de Georg Axhausen la 'corde de reconnaissance', seul lien qui, dans l'eau, permet la communica-

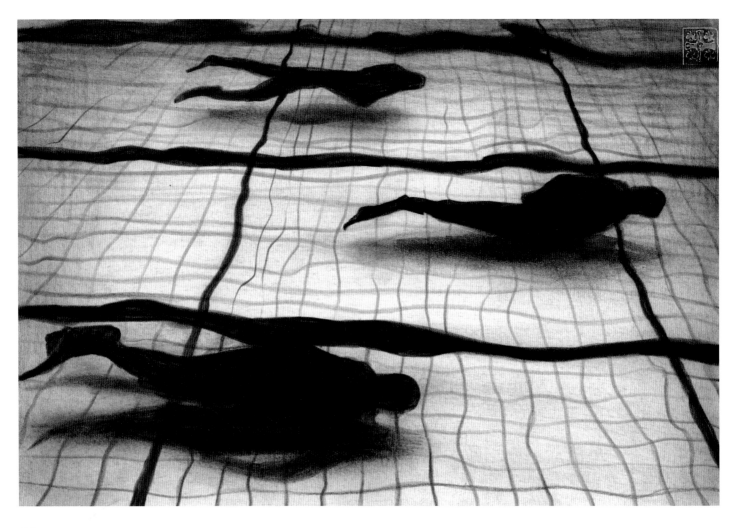

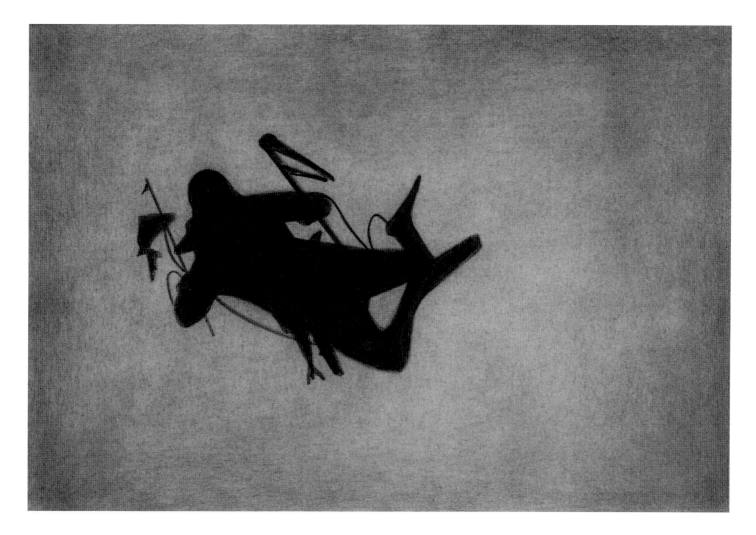

presse urgent

pour " wochenend " nuremberg

poitiers, 30. septembre 1949

le juge d'instruction de poitiers, me, roger a entendu un

temoin capital dans l'affaire des poisons de loudun, cont

l'accusee est m. wiegand. il s'agit de madame pintou

confidente des epoux wiegand, qui recuillit les confidences

de georg axhausen sur son lit de mort, celui-ci avait declare

"j'ai mange de la soupe empoisonnee aux liboureaux".

deux jours apres, il mourait.

sur 16 exhumations deja faites, on a retrouve treize

assassinats a d'arsenic

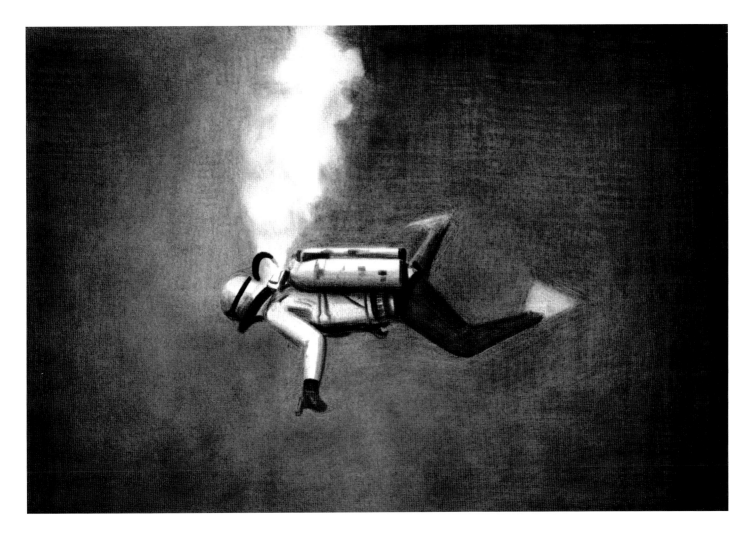

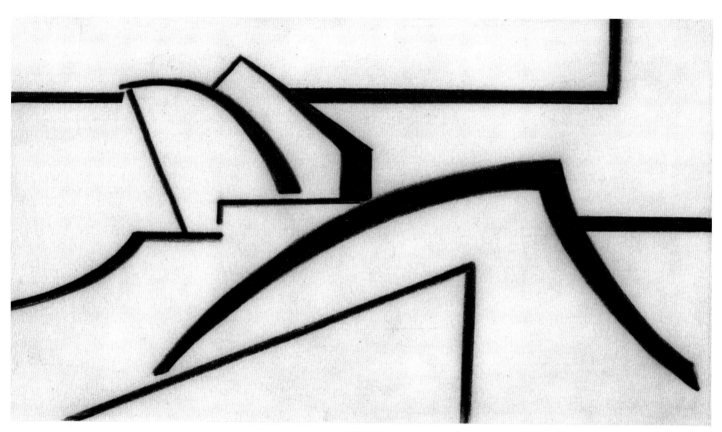

Georg Axhausen , 'Mercedes'
Öl , 60 x 90 cm

In dieser Ausstellung: ■

Axhausen

Ganz

Meyer

Wiegand

Galerie Schüler

Berlin W 15, Kurfürstendamm 51 ▪ T 91 63 61

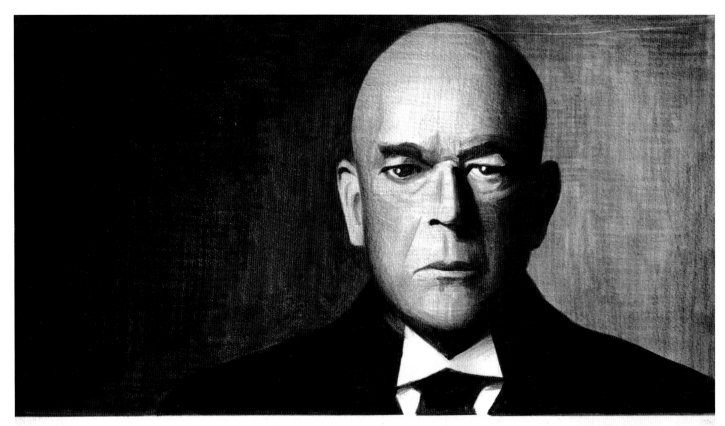

Paul Ganz

Paul Ganz, 'Radierung 2'
21 x 28 cm

CARRYING A GUN FOR AL CAPONE

By KM Wiegand

Revelations of a German-American Gangster

INSTANT WORLD SUCCESS

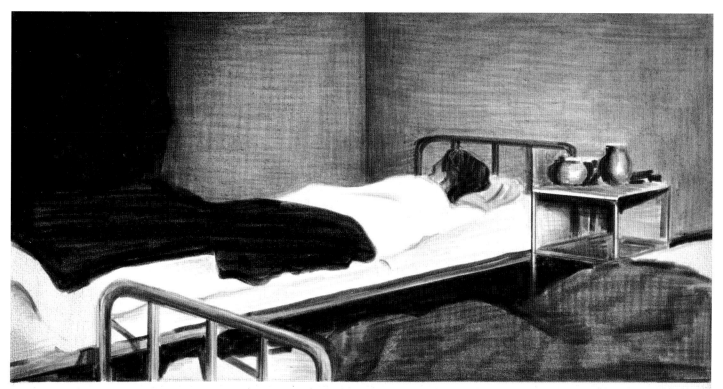

WIEGAND IST NOCH IMMER IN FREIHEIT, aber einige Mit-
glieder der Bande des ungekrönten Königs von Sizilien
sind der Polizei in die Netze gegangen. Jetzt werden sie

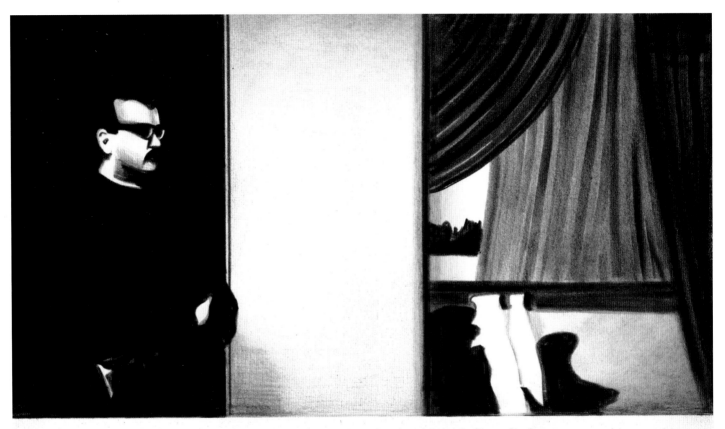

K.M. Wiegand, young abstract expressionist, has recently sold paintings to Whitney Museum and the Museum of

K.M. Wiegand, 'Plan I-61'
Casein, 42,5 × 47,5 cm

K. M. Wiegand, '15° – 55°'
Öl, 60 x 90 cm

K.M. Wiegand, '13° −59°'
Öl, 60 × 90 cm

K. M. Wiegand, '17° – 39°'
Öl, 60 x 90 cm

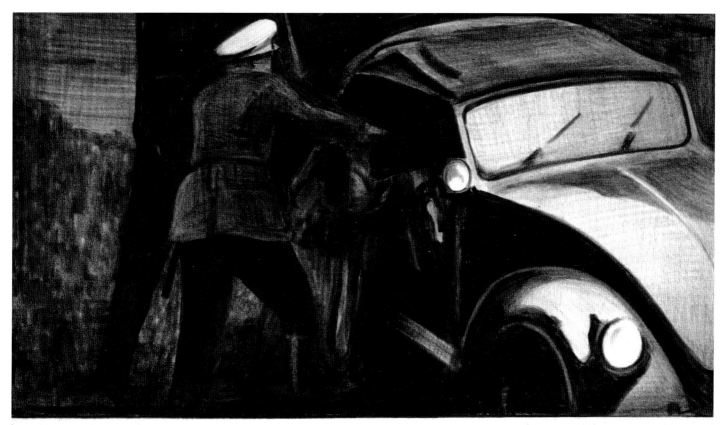

Mit vereinten Kräften wird Karl Wiegand auf den Rücksitz
befördert. Für einigen Jährchen ist es für ihn vorbei mit

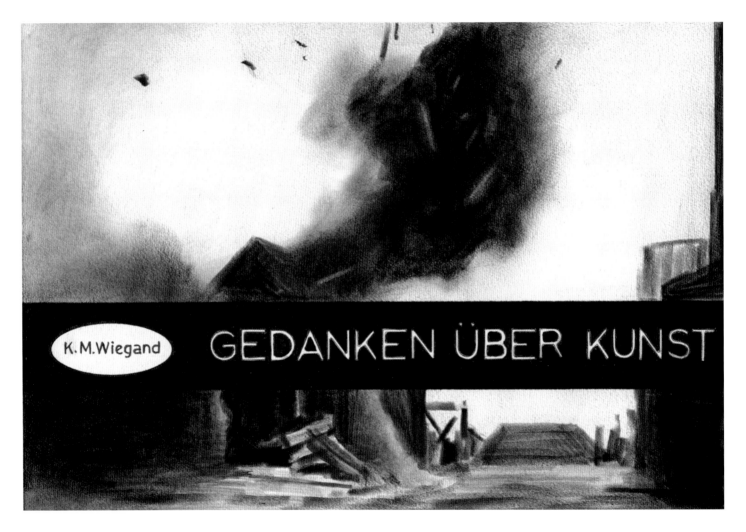

K.M.Wiegand GEDANKEN ÜBER KUNST

80

DRAWING

by K. M. WIEGAND

PITMAN

Gov. Brown
SAVE
WIEGAND

ITALIANS

NORWEGIANS

SAY

WIEGAND MUST NOT DIE

l'une des contrefaçons de Karl Wiegand: la signature du 'Lavement des pieds' (ci-dessous, pl. 15).

54. Schets door Wiegand op 24 Juli 1946 gemaakt.
Men ziet hierop een aanduiding van de compositie

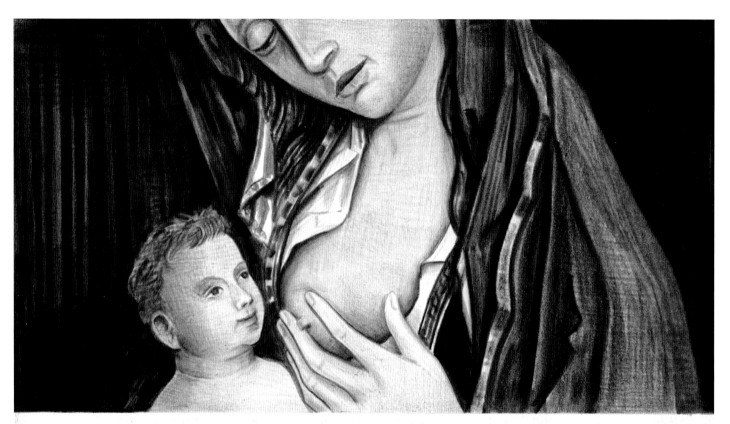

Detail van afbeelding 15. Copie van K. Wiegand naar
'De Heilige Maagd en het Kind' van Dirk Bouts.

Wiegand, 'Geist – Materie – Leben'
Bleistiftzeichnung, 47 × 67 cm

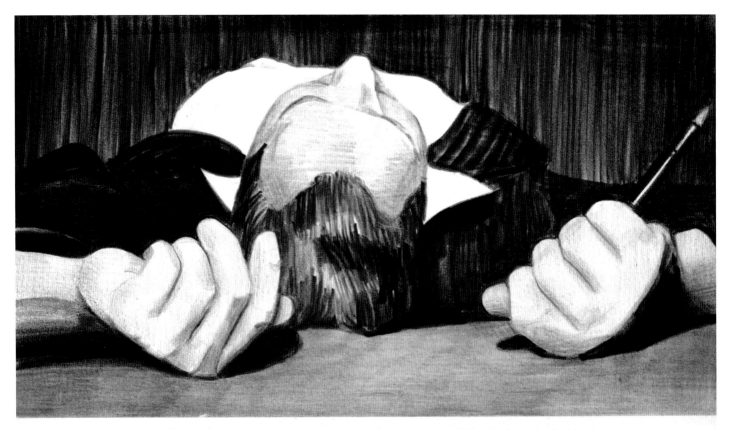

Wiegand glaubte, daß der Unbekannte ihn mit einem
Messer bedrohe, schoß, der Verfolgte stürzte im Korri-

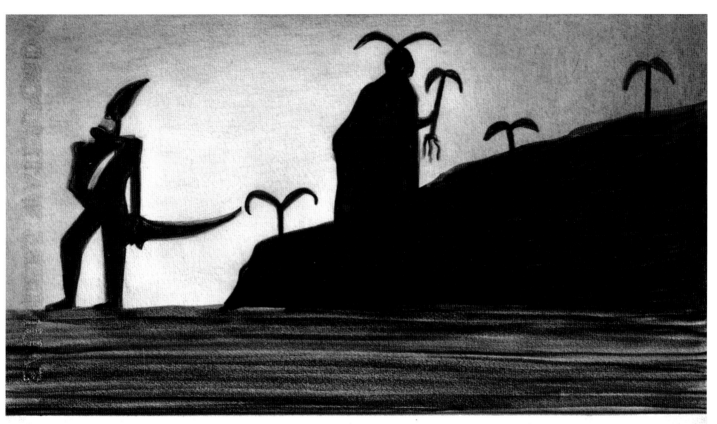

K. M. Wiegand, 'Lebemann'
Lithografie, 39 × 49 cm

K. M. Wiegand , 'Grün'
Radierung , 30 x 85 cm

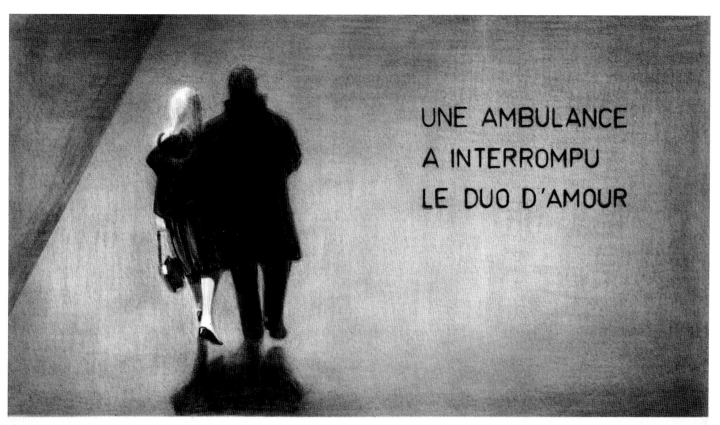

UNE AMBULANCE
A INTERROMPU
LE DUO D'AMOUR

Leur dernière sortie incognito: 3 jours avant le départ de Karl Wiegand la promenade d'amoureux.

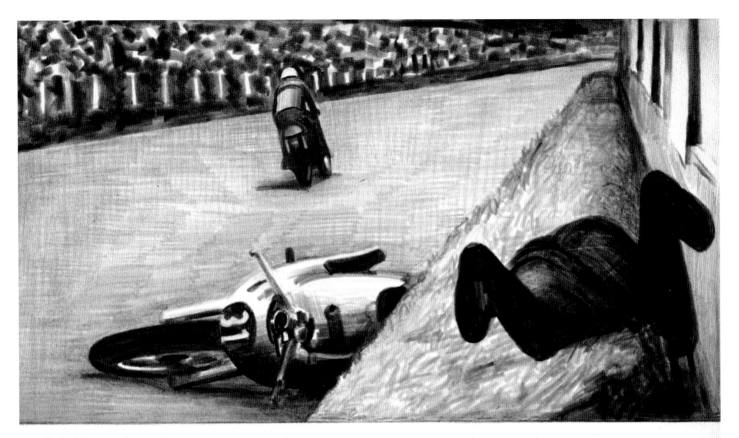

ALLEMAGNE – K.M. Wiegand, natif de Coesfeld, se trouvait
en bonne position derrière les leaders quand sa moto.

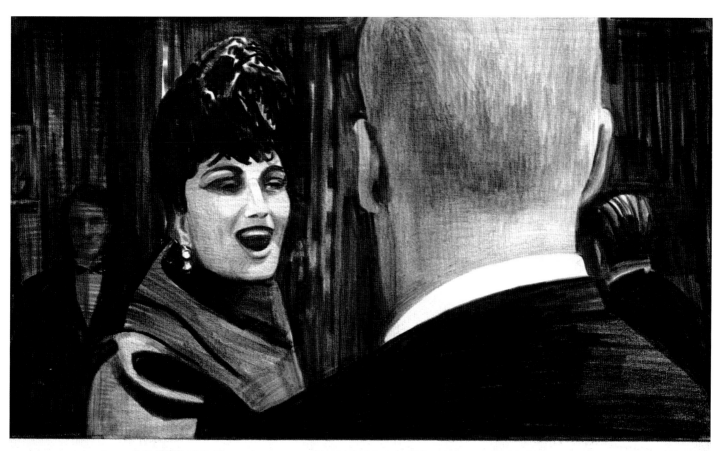

In 1957 Wiegand married film actress Jean Peters

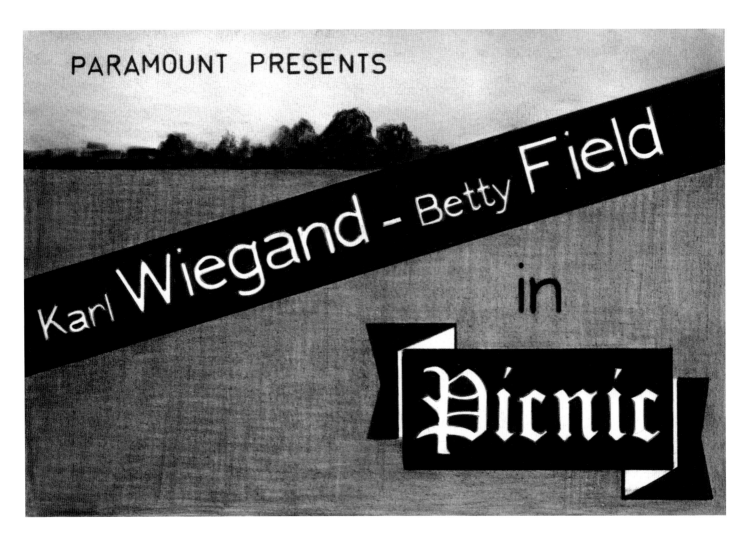

PARAMOUNT PRESENTS

Karl Wiegand - Betty Field

in

Picnic

94

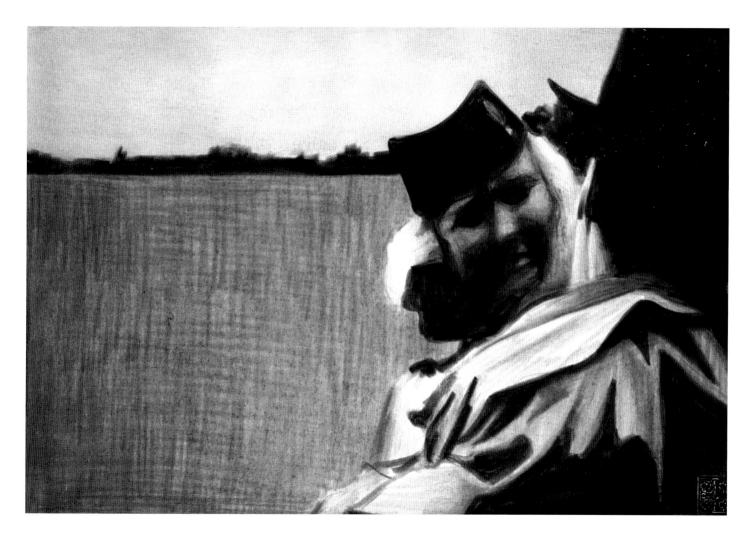

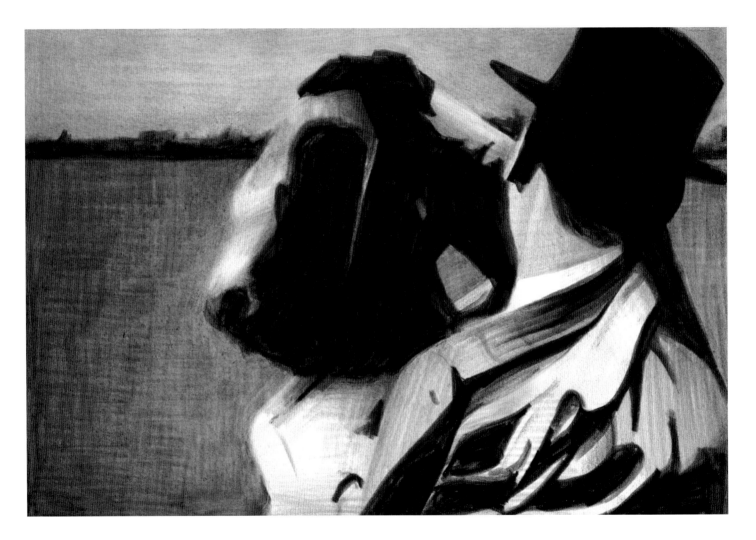

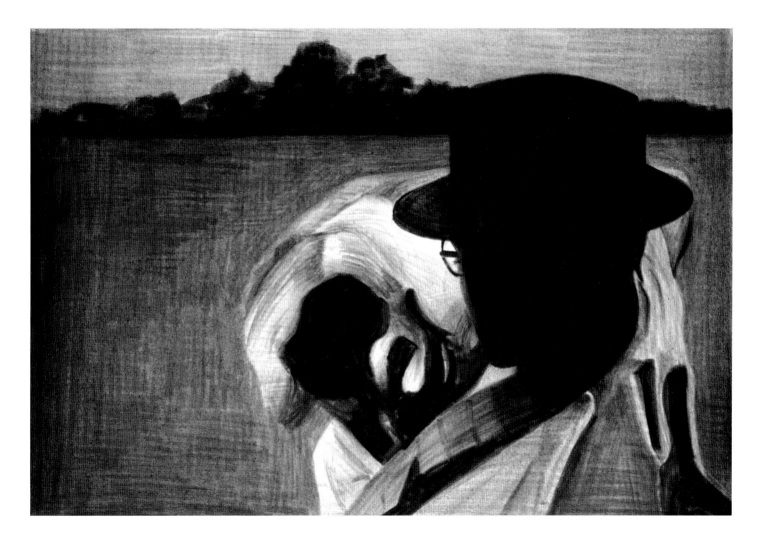

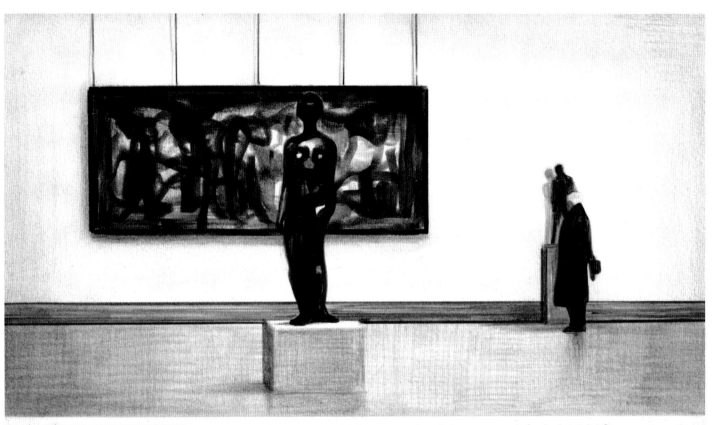

Ausstellung K.M. Wiegand
Galerie Karl Flinker, Paris

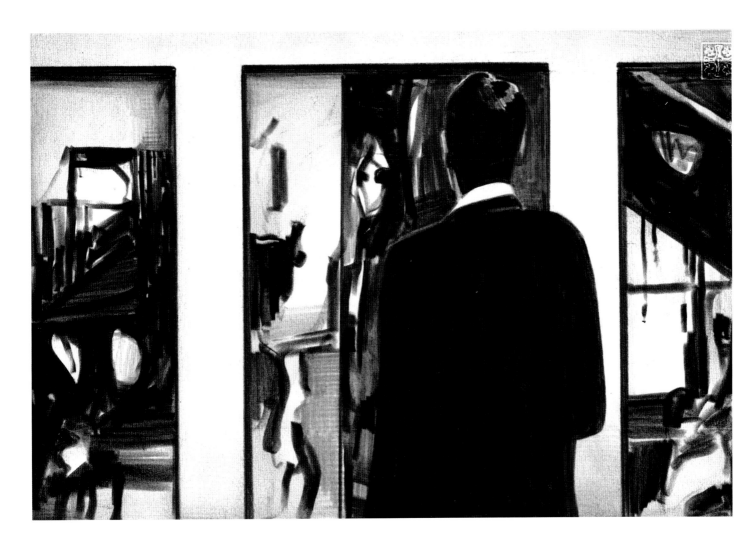

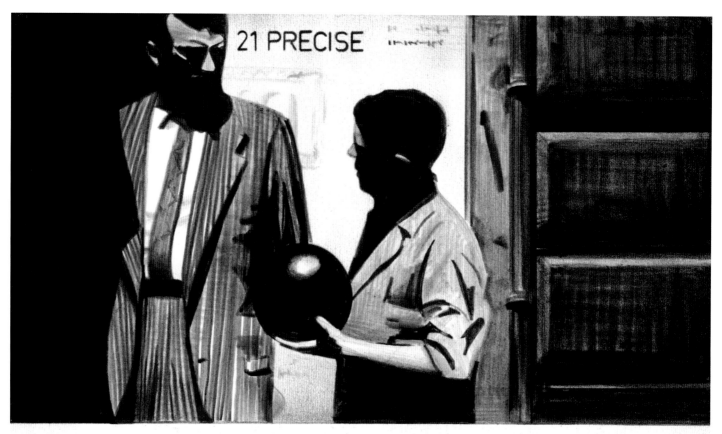

After a long career in romantic roles, Karl M. Wiegand
was considered "through" when Harry Sherman cast

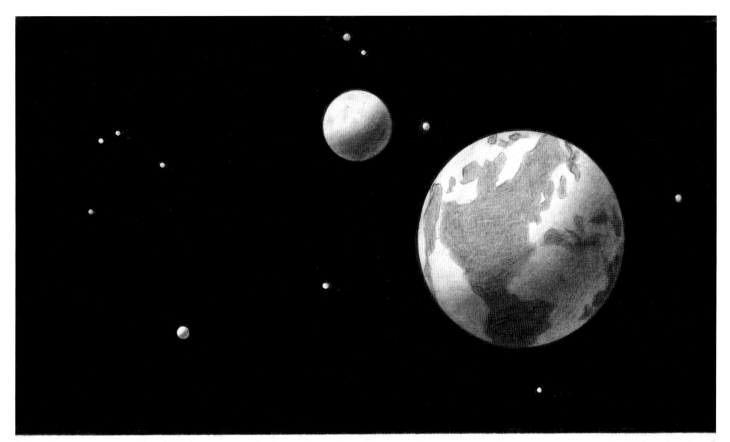

WIEGAND'S GIN the universal favourite

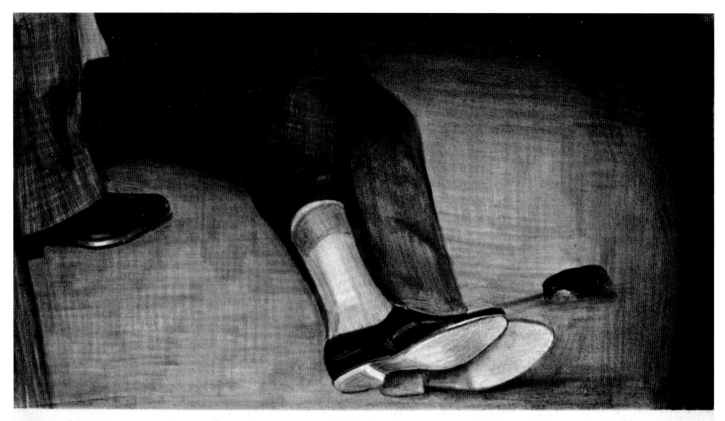

WHITE HOUSE GUARD Karl M. Wiegand, wounded in
both legs, gets first aid after the shooting is over.

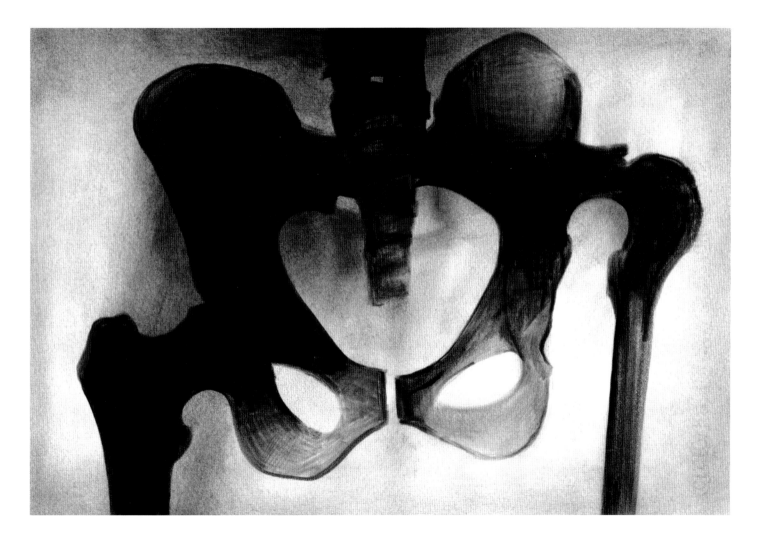

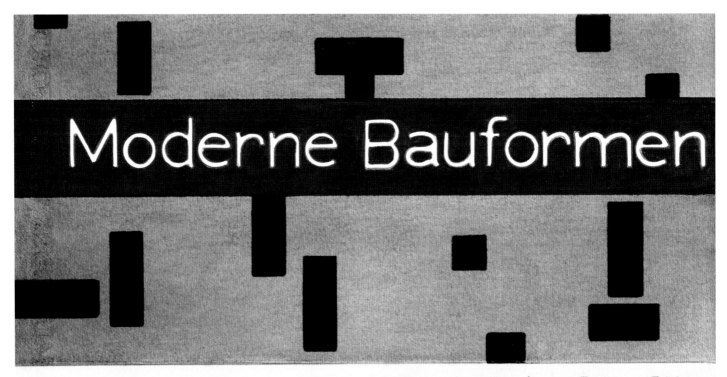

Moderne Bauformen

Monatshefte für
Architektur und Raumkunst
herausgegeben von K. M. Wiegand

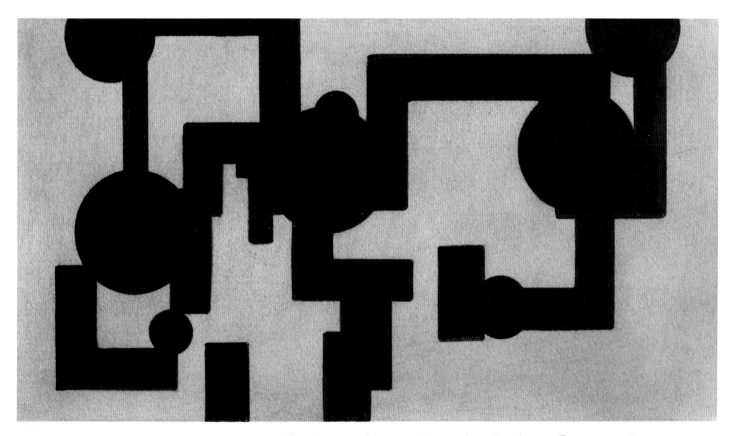

Extension d'un hotel a Copenhague
K.M. Wiegand

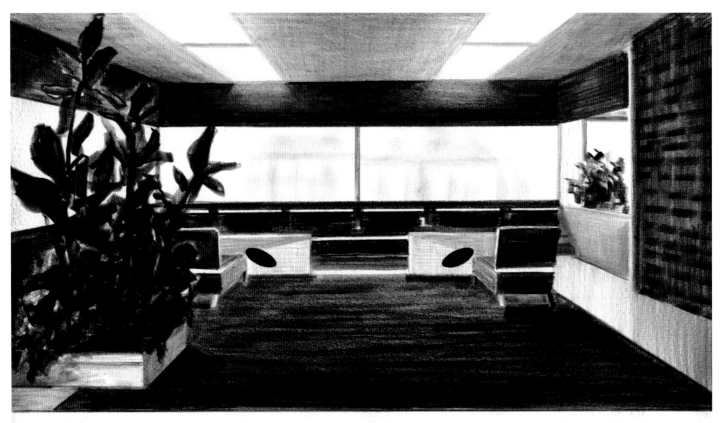

office, Chicago
H. Padtberg & K. M. Wiegand

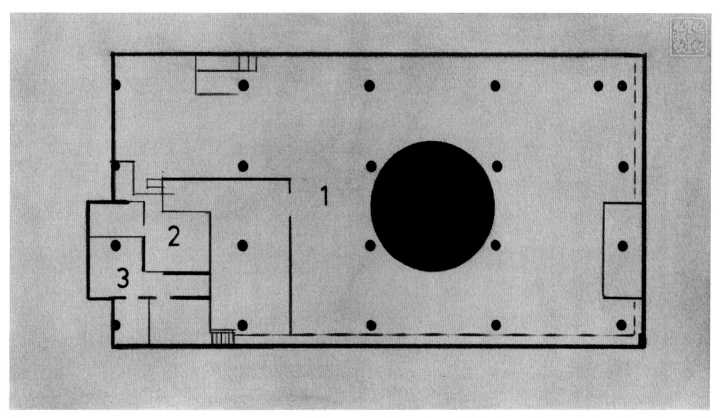

Warenhaus 'Galeries Modernes'
Untergeschoß 1:500, Axhausen und Wiegand

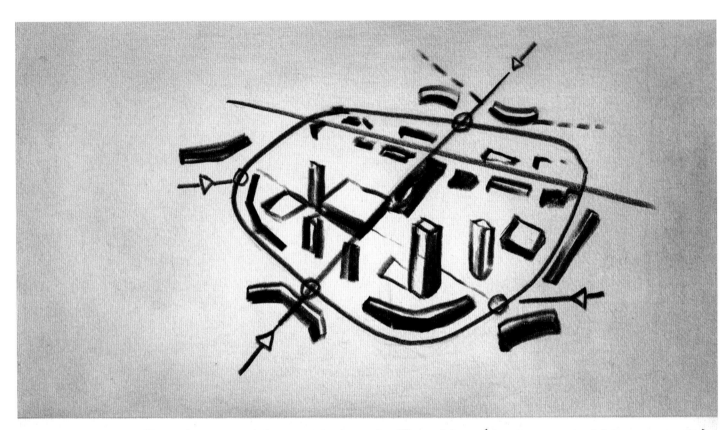

Zentrum Hauptstadt Berlin (Ideenwettbewerb)
Berlin, 1958 , K. M. Wiegand

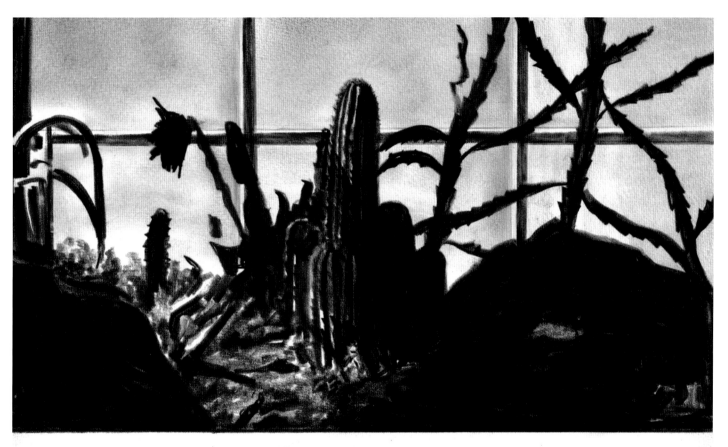

Kakteenfenster aus der Villa K. M. Wiegand

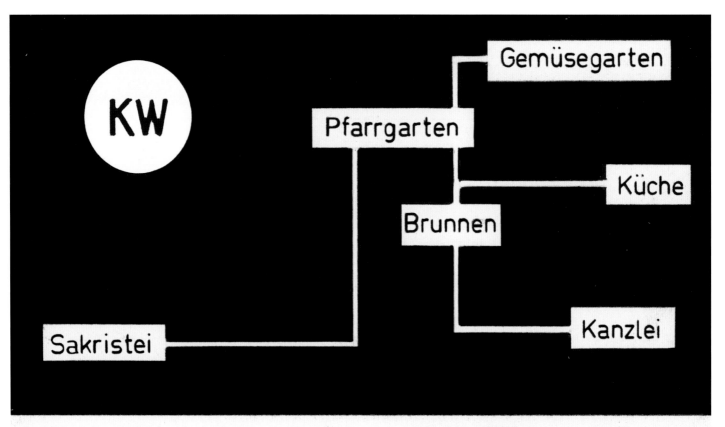

KW

Gemüsegarten

Pfarrgarten

Küche

Brunnen

Sakristei

Kanzlei

K. M. Wiegand, München
Erdgeschoßgrundriß; Ansicht S. 93

110

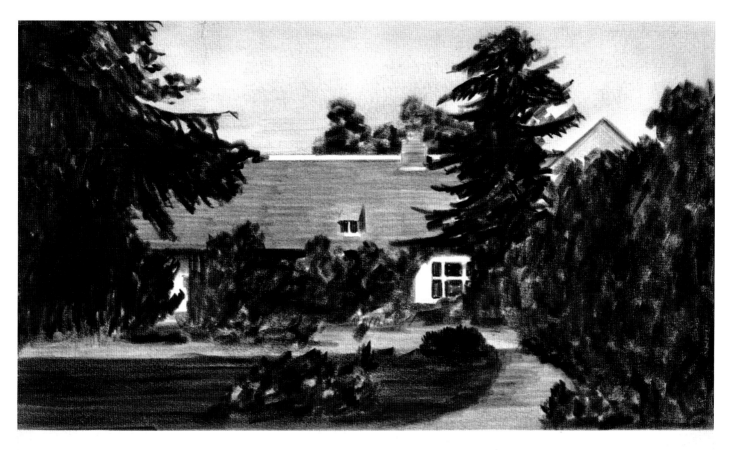

Pfarrgarten

ZU DEN HAUSENTWÜRFEN
DES ARCHITEKTEN (B.D.A.) K. M. WIEGAND

Die Art, wie der Bau-
künstler seine Gedanken
und Ideen darstellt, ist
von nicht zu unterschätz-
ender Bedeutung; von

ihr hängt es zumeist ab,
ob sein Wollen verstan-
den wird, ob der Bauherr

Aus einem Wohnzimmer

Erdgeschoßgrundrisse - Maßstab 1:400

Freude gewinne an dem,
was der Architekt ihm
auszubauen verspricht.

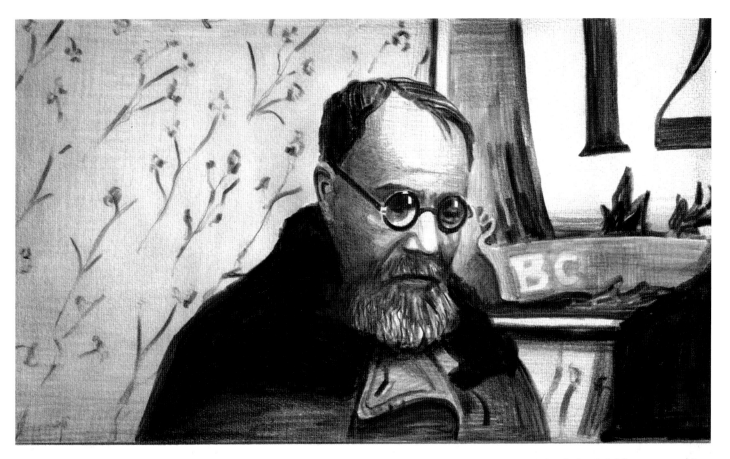

K. M. Wiegand

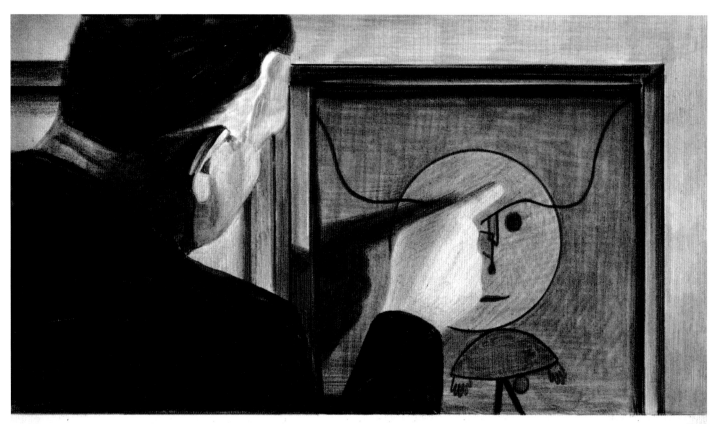

DETAIL in 'Misunderstanding in Green', one of Klees he
kept, is pointed out by Wiegand.

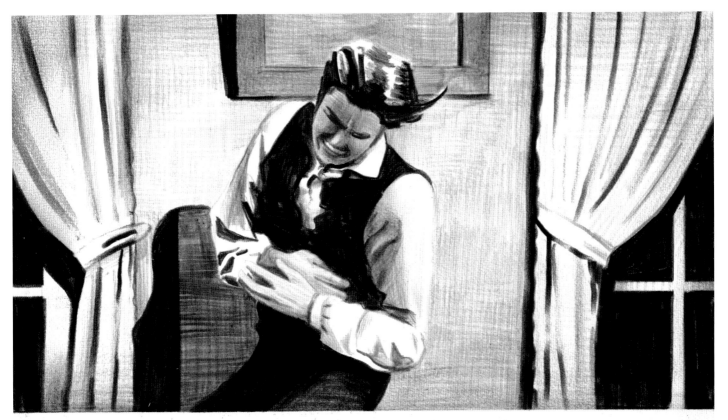

Jesse James, 1939. Mr. Howard's victim. K.M. Wiegand as
Jesse James is shot as he nails "God Bless Our Home" to

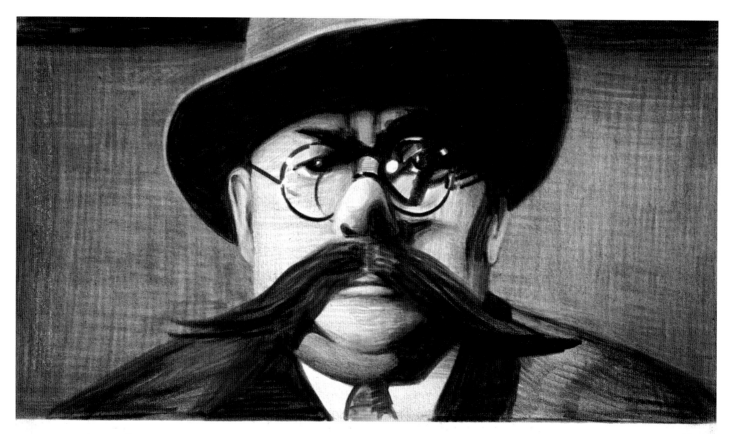

Karl Wiegand proved to be an outstanding screen find of the year for his powerful acting in THE MEN.

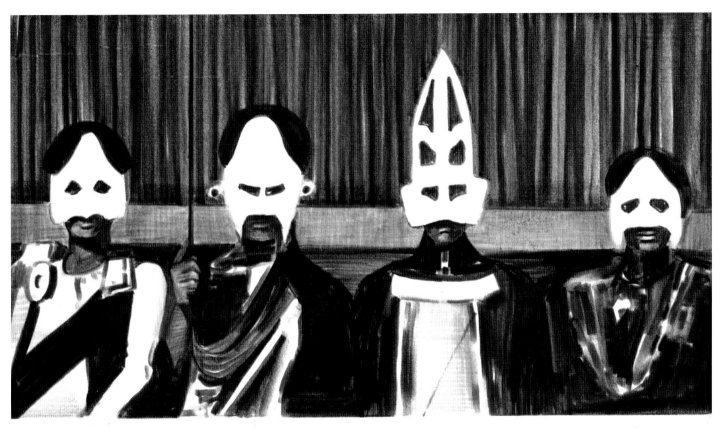

In Wiegand's THE BLACKS, a prime example of
existential theater, Negro actors don white masks in a

1953/54 PLAYERS

[handwritten signatures:]

Vim Bush

Carl Bn ——

connie Sammes

Jm Bauchbola

EmS Vanduyke

Ror Sue

Buddy Ackerman

Ed Smith

K.M. Wiegand

HARY PAULLETTE

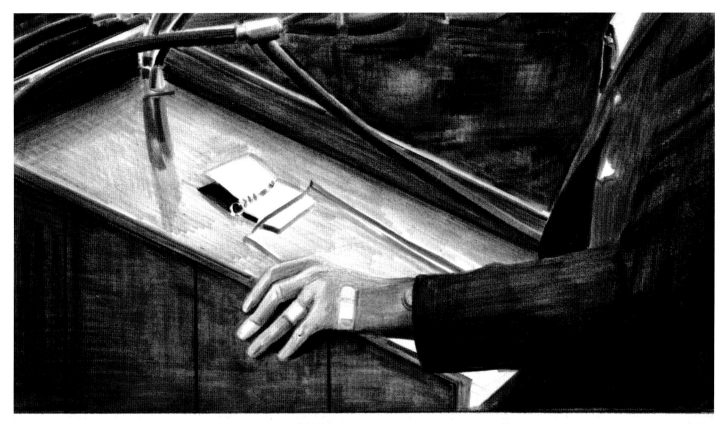

grasped Wiegand's hand so enthusiastically, as did sup-
porters elsewhere, that he had to wear bandages on his

K.M. WIEGANDS GRAPHIK

Nicht selten begibt
sich dies im Kunstbe-
trieb der Gegenwart:
Ein Künstler, dessen
Name einst zu allererst
genannt wurde, wenn
auf die Führer und die
Spitzenleistungen
einer neuen Bewegung

TITELBLATT ZUM „TOD VON BASEL"

die Rede kam, wird von
der hastigen, Welle über

120

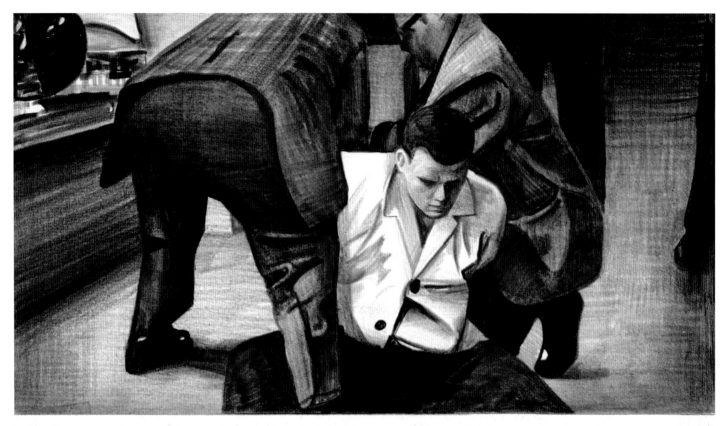

Wiegand pulled a gun, but threw it aside and tried to slug
it out with the police. He was overwhelmed and handcuffed.

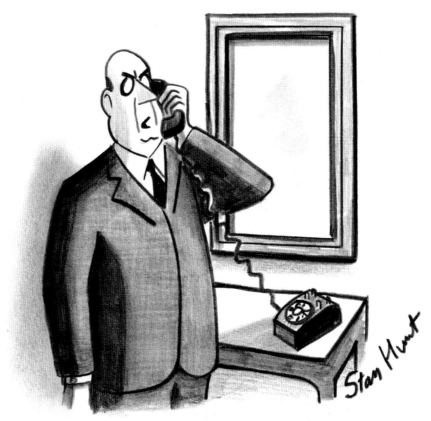

"Mr. Wiegand may or may not be in. Who is calling, please?"

K. M. Wiegand

Gardens

 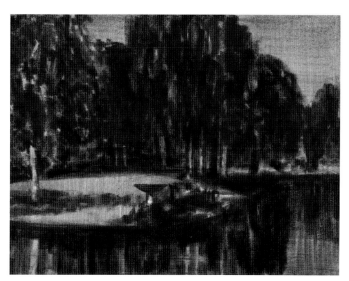

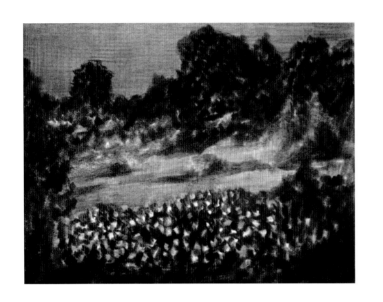 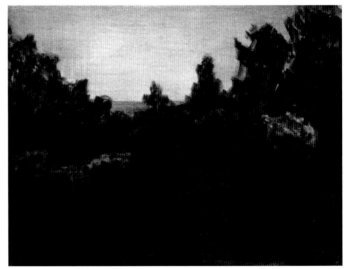

126

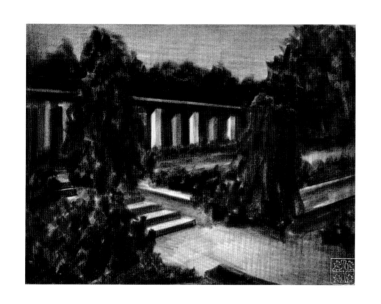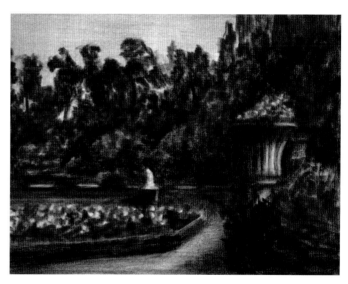

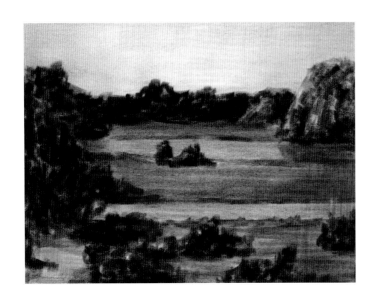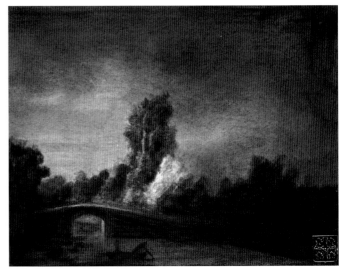

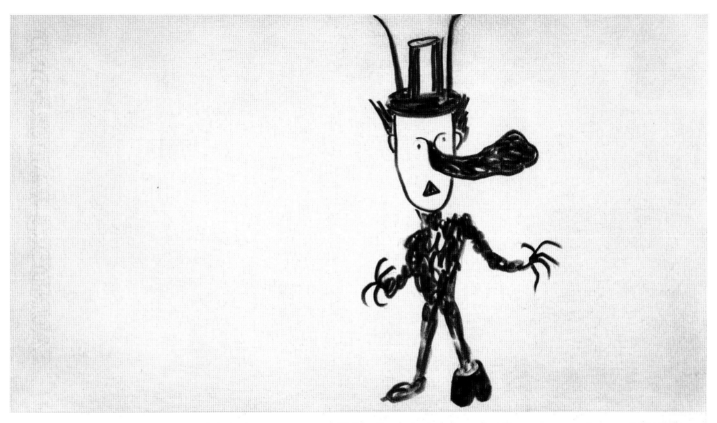

'Vision des Johannes', 1949
Wachskreide, 55 × 112 cm

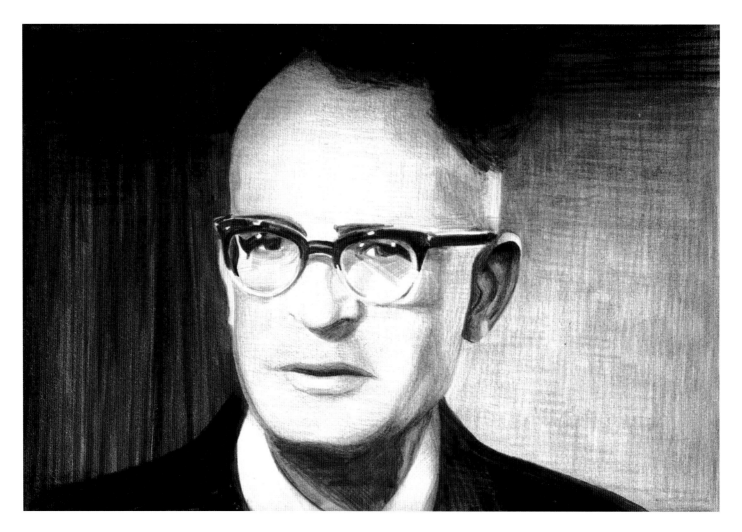

130

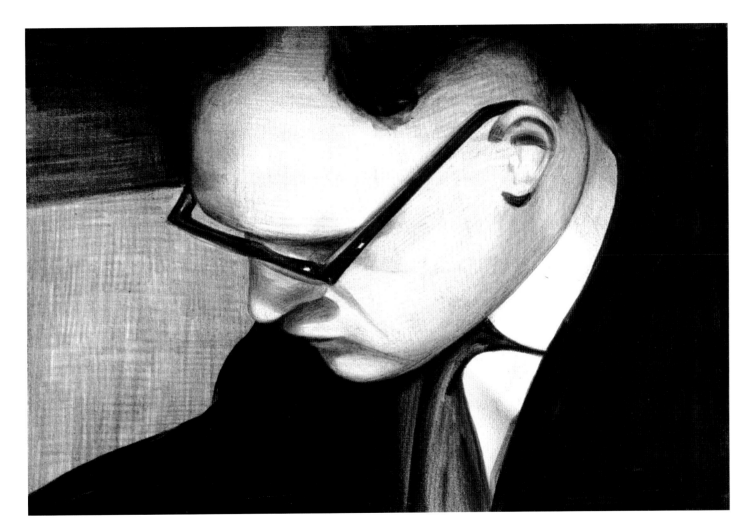

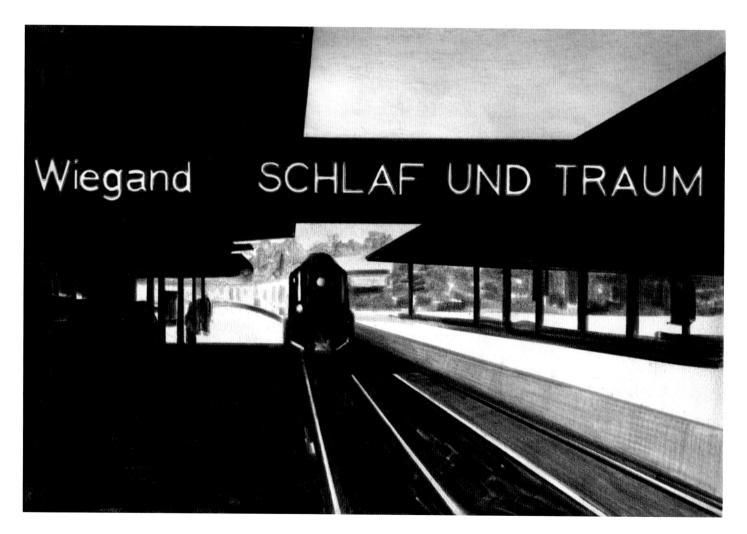

132

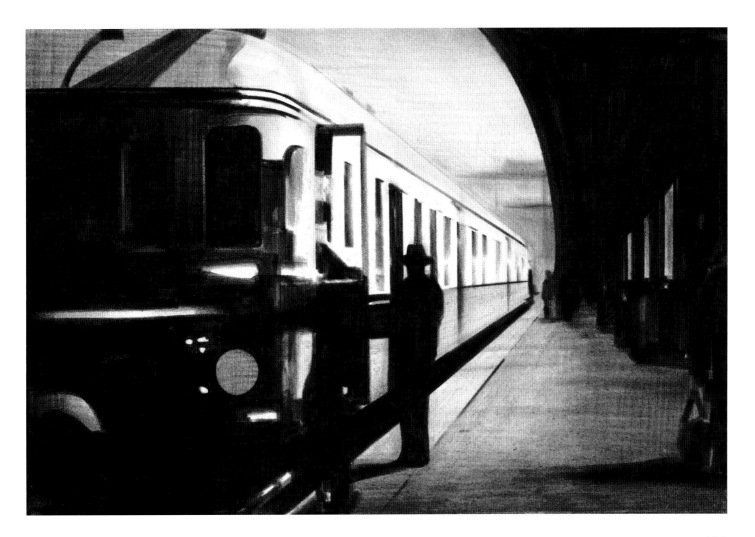

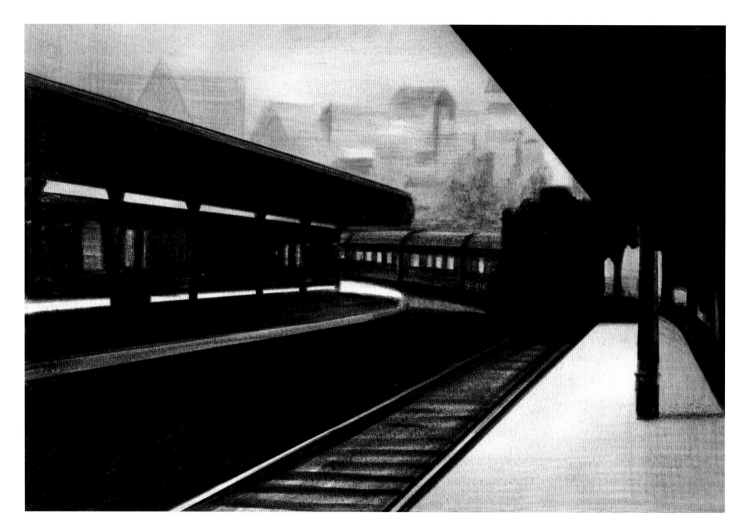

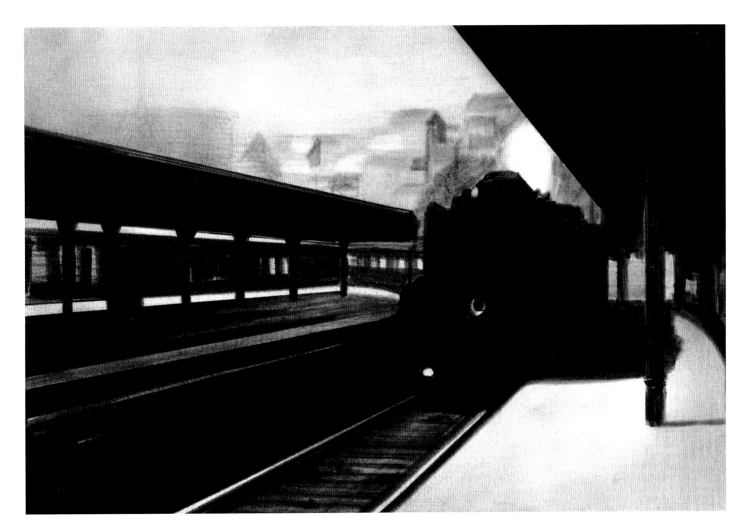

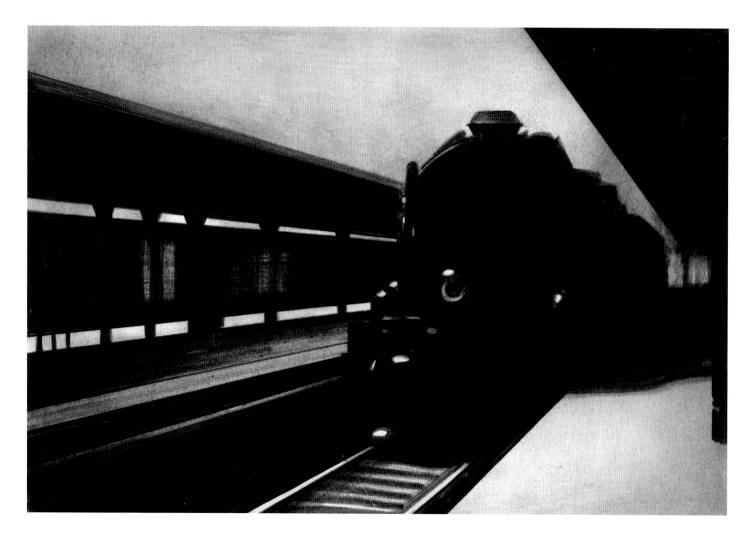

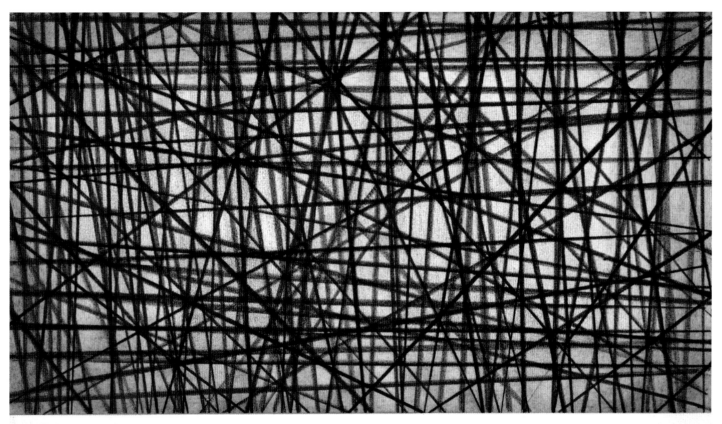

'Erinnerungen' , 1936
ÖL, 75 x 110 cm

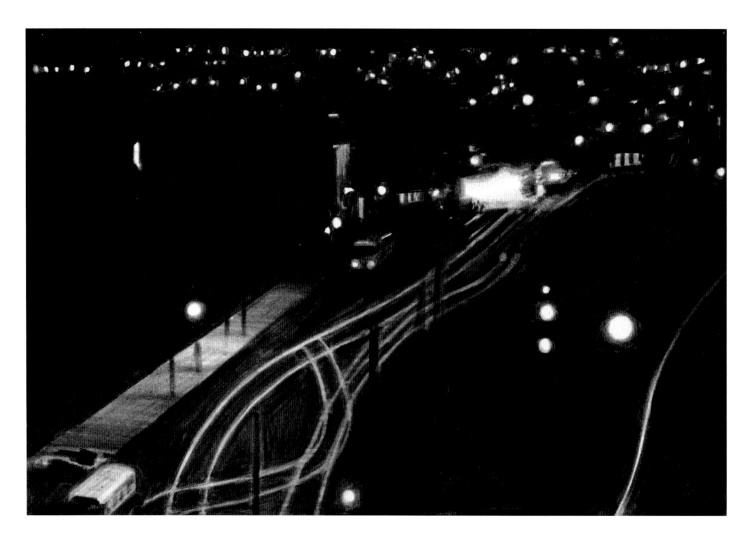

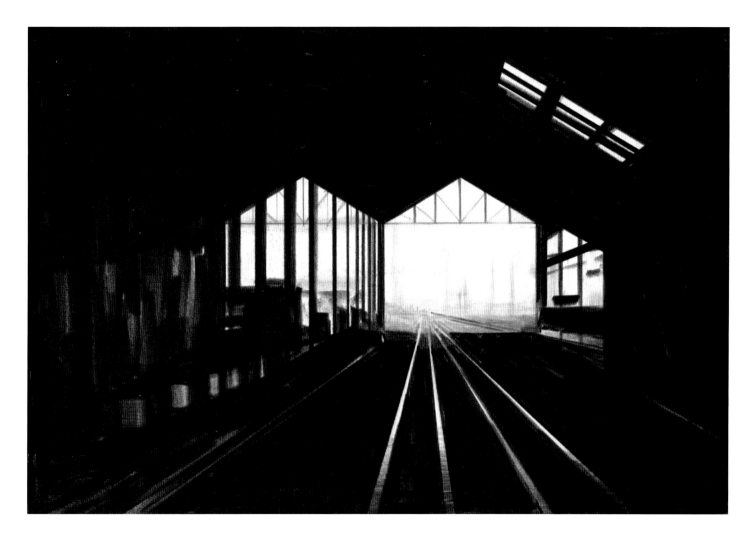

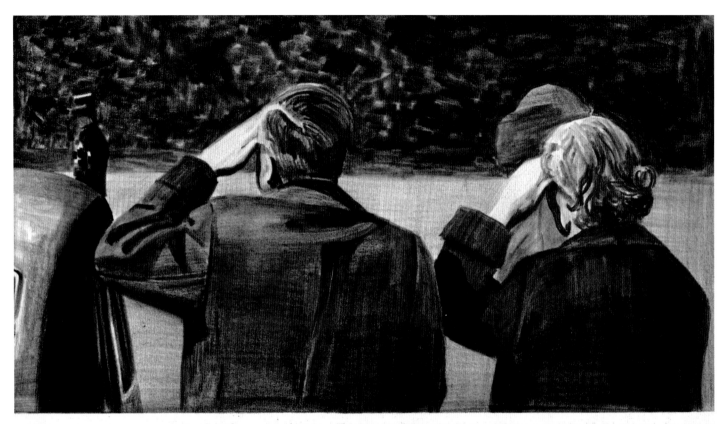

A L'ARRIVEE DE L'HELICOPTERE M. ET Mme WIEGAND
ONT EU INSTINCTIVEMENT LE MEME GESTE : FAIRE

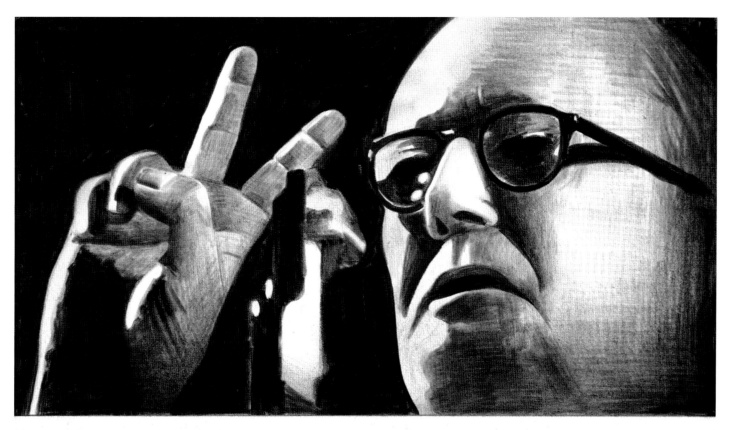

His fingers up in the victory symbol, K.M. Wiegand tells
his suporters in Pretoria that their mastery of South

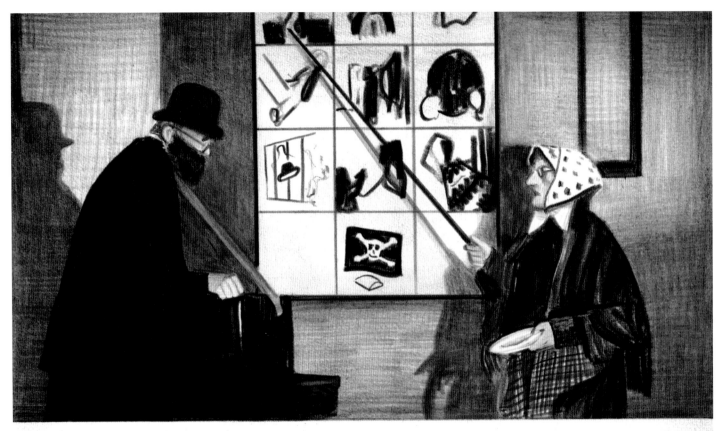

Wiegand begleitet mit der Handorgel eine Moritatensängerin

K.M. Wiegand, 'Feldberg'
Radierung, 40 × 50 cm

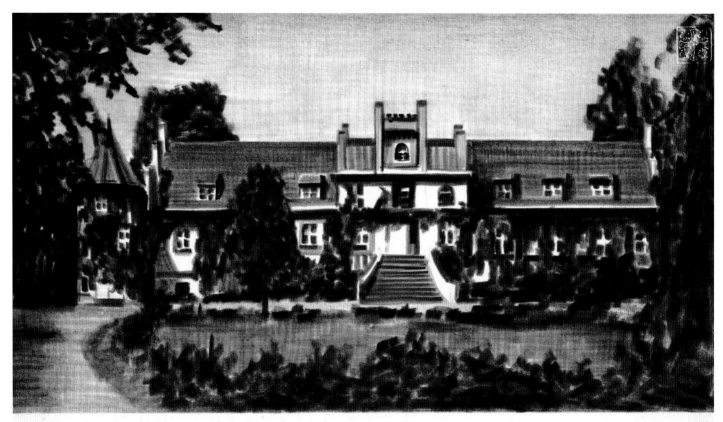

Het slot op het buitengoed Reckenwalde der familie Wiegand in Oost Duitsland.

K. M. Wiegand

62 BS II-63

Roman

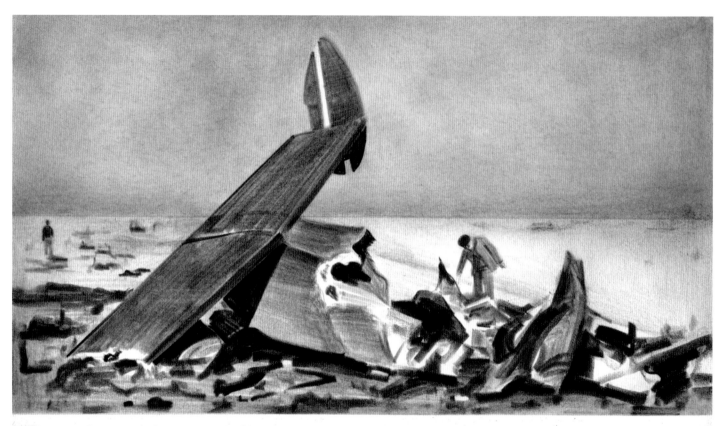

The story of K.M. Wiegand, who survived, is told by the au-
thor. The other survivor, Lieutenant Morales, disagrees

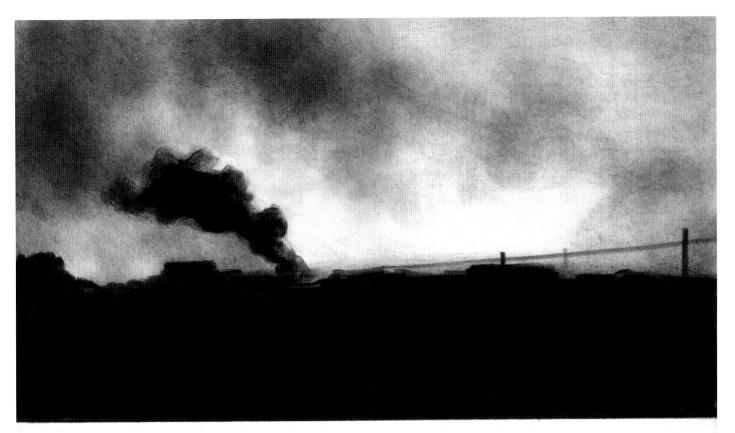

A rumor spread that Wiegand's plane had been sabo-
taged by Fascists – the Sinarquistas, perhaps, or the

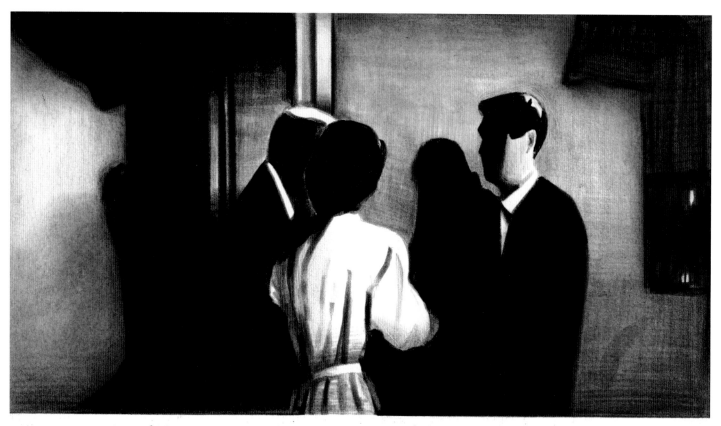

I served with Ambassador Karl M. Wiegand as his com-
mercial attaché. I had met him previously in Moscow;

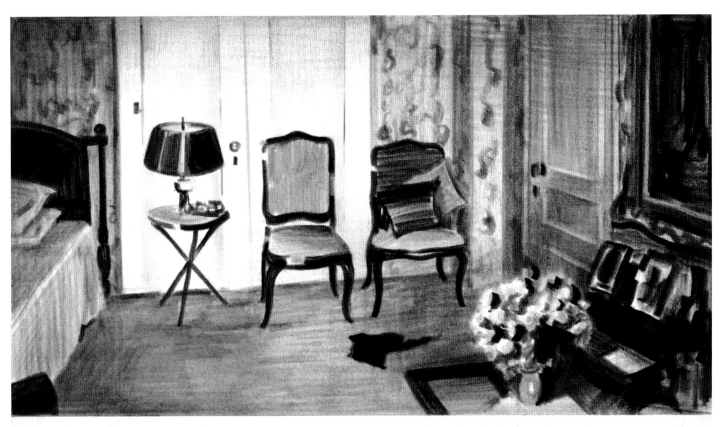

Karl Wiegand's bedroom had bloodstain on the floor
where his head lay after he turned and fell face down –

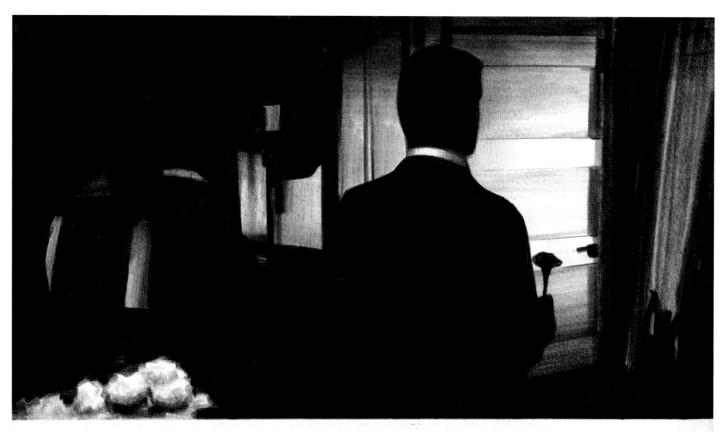

Consequently, I knew that Wiegand was not the Krem—
lin's fair-haired boy, as outsiders believed, but a man

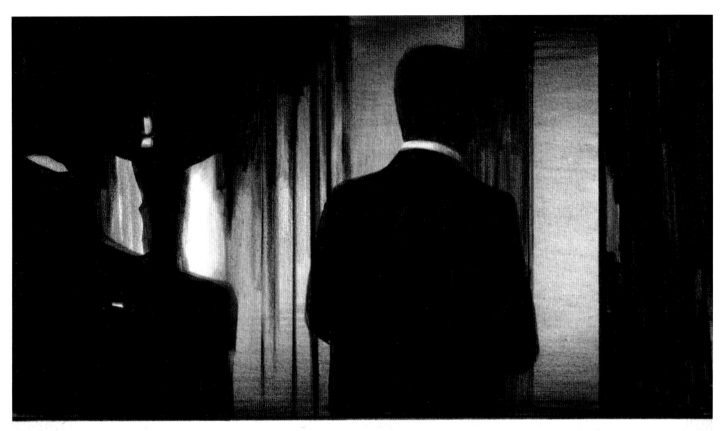

in secret fear of disgrace or arrest. Or worse. NKVD
spies surrounded him in Mexico. They had denounced

Note to the reader / Anmerkung

All drawings are in Negro pencil and were done in 2005–06. Those shown in large
illustrations measure 19 by 28 centimeters; those in small illustrations are 14 by 19 centimeters.
Alle abgebildeten Zeichnungen sind 2005/06 entstanden, mit Negrostift auf Papier.
Den großen Abbildungen liegen Zeichnungen mit den Maßen 19 x 28 cm zugrunde,
den kleinen mit 14 x 19 cm.

Marcel van Eeden

born in 1965 in The Hague / geboren 1965 in Den Haag
lives and works in The Hague / lebt und arbeitet in Den Haag

Solo Exhibitions (Selection) / Einzelausstellungen (Auswahl):

2006 Kunstverein Hannover

2005 Galerie Zink & Gegner, Munich / München
 Clint Roenisch Gallery, Toronto
 Wetering Galerie, Amsterdam
 Galerie Maurits van de Laar, The Hague / Den Haag

2004 museum franz gertsch, Burgdorf
 Institut Néerlandais, Paris
 Percy Miller Gallery, London

2003 Centro Galego de Arte Contemporánea, Santiago de Compostela
 GEM, museum voor actuele kunst, The Hague / Den Haag
 Wetering Galerie, Amsterdam

2002 Galerie Maurits van de Laar, The Hague / Den Haag

2001 Galerie Michael Zink, Munich / München
 Wetering Galerie, Amsterdam

2000 Teylers Museum, Haarlem

Publications / Publikationen:

Marcel van Eeden – tekeningen zeichnungen drawings dibujos 1993–2003,
ed. / hrsg. vom Institut für moderne Kunst, Nuremberg / Nürnberg, exh. cat. / Ausst.-Kat.
GEM, museum voor actuele kunst, The Hague / Den Haag, and / und
Centro Galego de Arte Contemporánea, Santiago de Compostela, Nuremberg / Nürnberg 2003.

Marcel van Eeden – Tekeningen, Wetering Galerie, Amsterdam and / und Galerie Maurits van de Laar,
The Hague / Den Haag 1998.

Marcel van Eeden – Tekeningen, Galerie Maurits van de Laar, The Hague / Den Haag 1994.

This catalogue is published in conjunction with the exhibition /
Diese Publikation erscheint anlässlich der Ausstellung
4th berlin biennial for contemporary art: *Of Mice and Men* /
4. berlin biennale für zeitgenössische kunst: *Von Mäusen und Menschen*
March 25–May 28, 2006 / 25. März–28. Mai 2006

Editor / Herausgeber: *Galerie Michael Zink*, Munich / München

Copyediting / Lektorat: *Tas Skorupa* (English / Englisch), *Monika Reutter* (German / Deutsch)

Translation / Übersetzung: *Christian Quatmann*

Graphic design and typesetting / Grafische Gestaltung und Satz: *Els Kort*

Typeface / Schrift: *Plantin / MonsterMash*

Paper / Papier: *170g/m² Hello Silk Crème*

Binding / Buchbinderei: *Verlagsbuchbinderei Dieringer, Gerlingen*

Reproductions and printing / Reproduktion und Gesamtherstellung: *Dr. Cantz'sche Druckerei, Ostfildern-Ruit*

Published by / Erschienen im

Hatje Cantz Verlag

Zeppelinstrasse 32

73760 Ostfildern

Germany

Tel. +49 711 4405-0

Fax +49 711 4405-220

www.hatjecantz.com

A special Collector's Edition is available. Please contact Hatje Cantz for more information. /
Es erscheint eine Collector's Edition. Nähere Informationen erhalten Sie beim Verlag.

Hatje Cantz books are available internationally at selected bookstores and
from the following distribution partners:
USA/North America – D.A.P., Distributed Art Publishers, New York, www.artbook.com
UK – Art Books International, London, www.art-bks.com
Australia – Tower Books, Frenchs Forest (Sydney), www.towerbooks.com.au
France – Interart, Paris, www.interart.fr
Belgium – Exhibitions International, Leuven, www.exhibitionsinternational.be
Switzerland – Scheidegger, Affoltern am Albis, www.ava.ch
For Asia, Japan, South America, and Africa, as well as for general questions,
please contact Hatje Cantz directly at sales@hatjecantz.de, or visit our homepage
www.hatjecantz.com for further information.

ISBN-10: 3-7757-1772-2
ISBN-13: 978-3-7757-1772-4
Printed in Germany

Cover illustration / Umschlagabbildung: *Marcel van Eeden*